Mary, Mother of All Nations

Mary, Mother of All Nations

Reflections by
Megan McKenna

Icons by
William Hart McNichols

ORBIS BOOKS

Maryknoll, New York 10545

The Catholic Foreign Mission Society of America (Maryknoll) recruits and trains people for overseas missionary service. Through Orbis Books, Maryknoll aims to foster the international dialogue that is essential to mission. The books published, however, reflect the opinions of their authors and are not meant to represent the official position of the society. To obtain more information about Maryknoll and Orbis Books, please visit our website at www.maryknoll.org.

Queries regarding rights and permissions should be addressed to:
Orbis Books, P.O. Box 308, Maryknoll, New York 10545-0308.

Published by Orbis Books, Maryknoll, NY 10545-0308

Manufactured in China

Library of Congress Cataloging-in-Publication Data
McKenna, Megan.
 Mary, mother of all nations: reflections / by Megan McKenna ; icons by William Hart McNichols.
 p. cm.
 ISBN 1-57075-325-3 (pbk.)
 1. Mary, Blessed Virgin, Saint - Meditations. 2. Mary, Blessed Virgin, Saint–Art.
 3. Icons. I. McNichols, William Hart. II. Title.
BT608.5 .M375 2000
232.91–dc21 00-034672

For all the poor who befriended me
and gave birth to the Word of God in me,
and for Eva, with gratitude
MM

For Steve, Bob, Mary, Margie, and their families,
and for the Society of Jesus
WHM

Contents

Introduction

Face-to-Face with Holy Presences

The word icon (*eikon*) simply means image. But in reality icons are much more. Almost as old as Christianity itself, they are intent on drawing the one who watches and sees into the very presence of the image "written" on the wood. Thomas Merton, a contemplative Trappist monk and writer-poet, was drawn to the Christ of the Byzantine icons. He writes:

> [Icons represent] a traditional experience formulated in a theology of light, the icon being a kind of sacramental medium for the illumination and awareness of the glory of Christ within us. . . . What one "sees" in prayer before an icon is not an external representation of a historical person but an interior presence in light, which is the glory of the transfigured Christ, the experience of which is transmitted in faith from generation to generation by those who have "seen" from the Apostles on down. . . . So when I say that my Christ is the Christ of the icons, I mean that he is reached not through any scientific study but through direct faith and the mediation of the liturgy, art, worship, prayer, [and] theology of light.

Always, there has been a secret to really seeing. The book of Exodus recounts the story of Moses seeing Yahweh face-to-face, with glory shining on Moses' face so strongly that the Israelites begged him to cover it. They could not bear to look at him after he had been in the presence of the Holy One of Israel (Exod. 34:30). And so Moses covered his face with a veil to hide the radiance. In 2 Corinthians, Paul writes about seeing

9

with this veil removed from our eyes — seeing with the eyes and light of the Spirit:

> Now this Lord is the Spirit, and where the Spirit of the Lord is, there is freedom. And we, with unveiled faces reflecting like mirrors the brightness of the Lord, all grow brighter and brighter as we are turned into the image [*eikon*] that we reflect; this is the work of the Lord who is Spirit. (2 Cor. 3:17–18)

The theologian Bernard McGinn, in the first volume of his classic, *The Foundations of Mysticism*, reflects on this passage from Corinthians:

> The word translated as "reflecting" (*katoptrizomenoi*) was often understood as "gazing" or "contemplating" (*speculantes* in both the Old Latin and the Vulgate translation). Thus, the text could be read to mean that it is by contemplation of the glory of the risen Christ that the image of God in us (Gen. 1:26) is being conformed to the Word, the Father's perfect Image (cf. Rom. 8:29; 1 Cor. 15:49; 2 Cor. 4:4). . . . The linking of contemplation and the perfecting of the image of God made this passage one of the most important in the history of Christian mysticism.

Icons are soul windows, entrances into the presence of the Holy. Like sacraments in the Western church, they are somehow, mysteriously, the reality that they image. Like the Word of the Lord — inspired by the Spirit of God — that evokes the presence of God as strongly as the Eucharist (bread and wine that are the body and blood of Christ), icons are believed to be sacraments that evoke this presence by sight and by faith. In the words of Paul Evdokimov: "In a nutshell, the icon is a sacrament for the Christian East; more precisely it is the vehicle of a personal presence."

And it is a deep, abiding silence, the silence of night, the silence of resurrection morning, the silence of a mother enrap-

tured by the eyes of her newborn, the silence of a father first seeing his child. It can fill a room as small as a monk's cell or as large as a cathedral — or a corner in the room of a house. It is an unassuming presence that seeps in gradually until it soaks through one's soul and heart and mind. Sister M. Helen Weier, O.S.C., writes of this presence and how it operates:

> The profound beauty of an icon is gentle. It does not force its way; it does not intrude. It asks for patience with the uneasiness of early acquaintance. It asks for time spent before it in stillness of gazing. More important, it asks the one praying to allow himself [or herself] to be gazed upon by it. One must yield space within...to the icon and its persistent beauty. An icon is prayer and contemplation transformed into art. When exquisite art combines with prayer to become a work of worship and wonder, the art becomes sacramental. It manifests to us the God who breaks through all signs and symbols with truth.

This presence heeds all the courtesies of friendship and the art of coming to know another with intimacy and depth. It teaches yearning, it can instill disquiet, and it calls us to linger. Yet it is an epiphany as indelible as Sinai or the Mount of the Transfiguration, for it is divine light loosed momentarily into the world, and it does not fade. It beseeches us to turn within and view ourselves with truthfulness, and it opens a space within us that does not close up ever again. It is a bit of this world that has passed from it, and, paradoxically, it returns again to this world and saturates it to its very roots. In the presence of an icon one senses God's carefulness with human beings, and yet one can tremble with a sense of the unfamiliar and the Holy reaching out to clasp us in an embrace of great tenderness.

An icon speaks a language: one of awe, reverence, canticles of blessing, litanies of detail and gladness, lament and sorrow that lead to adoration without words. Icons can introduce us

to "Jubilate Deo" and the profoundness of incarnation and res-
urrection with all the glories of the first freshness of morning in
the world. And yet they can similarly touch us with unbearable
suffering, the isolation of pain, and unending destruction. They
can evoke within us compassion, surging waves of sorrow and
grief, recognition of what evil can do to human beings. They
can summon up the fury of a prophet's anger or the fury of
faithfulness and justice. They incarnate one still point of the
Divine and let it linger, inhabit, and move in to dwell and stay
with us, taking over every room in our minds and souls. In the
presence of an icon we are never orphaned. There is always one
who whispers in our inner ear and comes like a breath of wind,
caressing our cheek, as once Yahweh sought intimacy with the
prophet Elijah at the entrance to his cave.

The Irish poet Sean Dunne wrote a grand poem about Mer-
ton's hermitage in Kentucky. It is called "Five Photographs by
TM." One of the "photographs" is called "Icons." It reads:

> From a distance, they might be framed
> Pictures of high-school friendships,
> Students with scrolls and gowns,
> Family portraits in studios.
> Closer, a worn madonna pines
> On painted wood. Near her, the flecked
> Faces of prophets stare.

He amply captures both the sense of familiarity and the an-
cient wisdom and otherness that icons reveal. In a room they
dwell with us, yet still remain somehow in the presence of the
God of heaven. In the mediums of wood, egg tempura, and
gold leaf and in the disciplined expressions of archetypal fig-
ures we are met by the old and new friends of God whom
we are called to cherish as they cherish the children of God
who are still on earth. Whether the icons are of Christ, the
Mother of God, the Trinity, the descending and transforming
Spirit, the beloved Father, or one of the many angels, saints,

and prophets, they all are about revelation. They all invite us to meet face-to-face with the presence portrayed — "written" — on the icon. Theology, belief, spirituality, and prayer all merge in the one who sees and is seen by the presence on the icon. To look, to contemplate, and to begin to pray is to be transformed, to be radically altered, and to draw near to the holy ones of God. We are invited to become part of the icon, part of the story of God, part of these persons' experiences of God, and to know and be known by the Holy. In a sense, one is read by the icon, seen through, exposed. It is humbling, excruciating, freeing, and rapturous. We are taken to the source of what we see.

This is a book of icons of the Mother of God. Pope John Paul II writes of Mary, who, in John's gospel (John 19:26), stands witness at the foot of the cross:

> She is Mother to all and Mother forever. The goal of her mission is to reproduce in believers the features of her firstborn Son (cf. Paul VI, Apostolic Exhortation *Marialis cultus*, 57), bringing them at the same time to recover ever more clearly that image and likeness of God in which they were created (cf. Gn 1:26).
>
> The faithful know they can count on the heavenly Mother's concern: Mary will never abandon them. By taking her into their own home as a supreme gift from the heart of the crucified Christ, they are assured a uniquely effective presence in the task of showing the world in every circumstance the fruitfulness of love and the authentic meaning of life.

Always the icon is about contemplation, but surprisingly so. The woman who contemplated her newborn child with utmost awe and sheer delight is also the woman whose soul was shattered as she saw the horror of hate that destroyed the body of her beloved child grown to be a man. A simple definition of contemplation is a long, loving look at reality, especially real-

ity that is hard to look at. The soul of Mary contemplates God becoming flesh in the world and, like her child, "growing in wis-dom, age, and grace" through that mystery of contemplation. Listen to John Damascene as he writes of Mary:

> It was necessary that she who contemplated her own son on the cross, and who had been pierced through the heart by the sword she had avoided while giving birth, should contemplate him reigning with the Father.
>
> If we firmly abstain, then, from past vices and love the virtues with all our heart, taking them as our companions in life, the Virgin will frequently visit her servants, bring-ing all manner of blessings. She will be accompanied by Christ her Son, the King and Lord of all, who will dwell in our hearts.

Mary unveils the face of God for us. We are told in Luke that this was the manner of her living and praying as she pondered all these things in her heart. She sought always to see with eyes of faith, of understanding, of accompaniment, and of devotion. She sought to make meaning of what God was doing not only in her own life but in the long history of her people and in the remnant that waited for the coming of the Holy One. Mary was an icon herself, as she watched God watching the world. St. Catherine of Siena writes in prayer:

> O Mary, my tenderest love!
> In you is written the Word from whom we have the
> teaching of life.
> You are the tablet that sets this teaching before us.
> I see that this Word, once written in you,
> was never without the cross of holy desire.

The poet Rumi urges his followers to fast, but his words could be used to encourage us to imitate Mary as she contem-plates God:

Feed on the Light, be like the eye,
be in harmony with the angels, O best of humankind.
Like the angel, make glorification of God your sustenance.

Mary is a written icon! And so an icon of Mary seeks to write
us as words of her son, the Word of God. We gaze upon her
and her child, and the ancient symbols of intimacy with God,
of holiness and divinity, come close in our own flesh — and
she looks right back at us! Even when she is looking straight at
her child there is the sense that she is looking at us, her other
children, all of us. She is so intimately bound in life, in love,
in experience, in history, and in the Spirit to this Word, her
Child-God, that she cannot be separated from the presence of
God made flesh among us.

In many icons, especially traditional ones, the perspective is
reversed. Instead of the viewer looking off in the distance, to-
ward the horizon, the perspective comes from the icon toward
the one who is looking at it. The icon is the eye of God glanc-
ing in our direction, and so all things in the icon come from
that singular point of view. This perspective draws us into the
mystery, toward the subject of the icon. We are the object of
the image's intense concentration and questioning gaze! And
so, in this book, Mary, the Mother of God, is always looking at
us, singling us out for contemplation, for transformation, and
for grace as she draws us into God's presence.

Traditionally, all icons of Mary, even those of the virgin and
child, are labeled "Mary, Mother of God, and Jesus Christ,"
in Greek letters at the top of either side of the icon. It is the
signature of those who beckon us and invite us closer. And,
as you will notice in many of the icons in this book, Mary is
ritually clothed in the priestly vestments of the Byzantine rite,
bordered in gold and decorated with wrist cuffs. She is priest
and mother, and the wood of the icon is also the wood of the
cross and altar. Encircling her head or her child's or both of
them is a mandala. In a few of the icons this orb, or oval, often

in the shape of a circle or an egg, will enclose her child in her womb. This ring of light is a written symbol of the presence of the Divine. The other letters that are often written inside the halo or mandala of Jesus, even as an infant or child, are the three Greek letters that are the name of God in the Old Testament: "I Am Who I Am." Mary's child often has his hand raised in blessing with two fingers open and three fingers closed. This reveals the doctrine of Jesus Christ as both human and divine as well as his nature as a person of the Trinity. This is all part of the language of seeing and knowing that is the heritage of the Eastern church, which has long referred to Mary as God's "Forth-bringer."

This Eastern church daily sings a song called the "Akathist" hymn, composed in the fifth or sixth century. Toward the very end of the long hymn appear the lines:

> We see the Blessed Virgin as a lamp of living light shining upon those in darkness; she enkindleth an unearthly light to lead all unto divine knowledge; she, the Radiance that enlighteneth the mind, is praised by our cry:
>
> > Hail! ray of the spiritual Sun.
> > Hail! ray-flash of never-waning light.
> > Hail! lightning-flash illuminating souls.
> > Hail! thunder clap frightening foes.
> > Hail! thou who sendest forth manifold splendor.
> > Hail! who wellest forth a many-streamed river.
> > Hail! who imagest Siloam's pool, . . .
> > loving-cup brimming with gladness.
> > Hail! odour of Christ's sweetness.
> > Hail! life of the mystic feasting. (pt. 21)

These images of Mary are ancient in the church. Whether in word or in visual symbol, they are written for the eye of the heart and mind. Although the images in this book are more contemporary, they are sourced in these memories, beliefs, and

centuries of prayer from the Scriptures and the many traditions of spirituality in the universal church. Some images of the Mother of God relate to her life on earth, telling the story as it has come down to us in the gospels. These describe the ancestry of Mary, the nativity and raising of her young child, Mary as mother of the Incarnate Word, the woman of sorrows. Other image titles or aspects, endlessly creative, that have come down to us through devotions and experiences of the church include the woman of the Apocalypse of John, Maris Stella, Mary Similar to Fire, Mystical Rose, Fairest Love, Loreto, Madonna della Strada, Gate of Heaven, Burning Bush, the New Advent, Light in All Darkness, Queen of Pilgrims, Ark and Tabernacle, and Lap.

Others are connected to a specific place on earth and an awareness or devotion to Mary, the Mother of God, as experienced in history and geography. These titles incorporate the following place-names and aspects: Vatopedi, Yaroslavl, Pochaev, Loreto, Paris (The Miraculous Medal), Rome (Della Strada), Magadan, the Sandias, Medjugorje, Holy Protection. The vastness and range of this Mary, the Mother of God, are perhaps best caught in Mary Most Holy, Mother of All Nations. There is an endless variety of names and images that give a universal and timeless quality to her images. As there is a "spaciousness in her womb and soul," there is also a spaciousness to her presence on earth.

Perhaps the strongest set of these images are those that are somehow bound to the symbol of fire. Some are prophetic icons that are apocalyptic, bearing messages or tremors that wound, that confront and cry out visually to us to take heed of our world as seen through the eyes of Mary, the Mother of God. Some of the icons of Mary associated with images of fire are those whose titles contain the following names or qualities: Similar to Fire; Pochaev; Kosovo (Pilgrims); Miraculous Medal; Prophet (Medjugorje); New Advent, Burning Bush; Apocalypse; Light in All Darkness; and Mother of All Nations.

These icons are laced with terror and the horrors that human beings conceive. They are born of our voracious and unnatural appetite for violence. These icons reveal our face as convulsive, wreaking havoc on the weak and those who are different or other than us. These images put place-names on an experience when the number of victims and the sheer immensity of evil begin to overwhelm us — places such as Kosovo, Sierra Leone, Northern Ireland, Rwanda, Bosnia, Soweto, Salvador, Magadan, the West Bank and Bethlehem, and East Timor. They remind us, at once, of a hill called Golgotha, the Place of the Skull. Every generation must learn to confess, to make firm purpose of amendment, and to religiously avoid repeating these evils ever again.

This strain of violence and rage has ever been known by iconographers, whose history has been one of persecution and the maiming of eyes and of hands. The icons themselves can elicit responses that are brutal, such as the scratching out of the eyes of the virgin and child. History teaches that with the Word alive inside us, or with the expression of this Word painted or written on wood, we are in danger. Being born into a Christian life in this world situates us on the side of truth and so puts us in jeopardy if we honor that truth in our lives.

The ancient Jews believed with a confidence born of God's revelation that human beings are enmeshed in a struggle between an evil, malevolent urge and a holy urge to do and to be good. Once evil is done, it cannot be undone; yet it can be repaired, remedied — what is called *tikkum olam.* This is the work of a life lived righteously, religiously — alone and in communion with others and with the will of the Holy One.

Icons are a work of *tikkum olam.* They are a remedy, a radical reminder of the good, a proclamation of hope incarnate, standing and judging the world that kills, maims, destroys, and humiliates humankind and selfishly wastes the earth's resources. An icon reweaves a small portion of the universe into

communion and makes holy the here and now. Icons whisper, "Remember! Come together again, as it was in the beginning and will be once more."

An icon is a prayer. It is God's prayer and supplication to us to heed once again the command to "Know that I am God, there is no other before me" (Exod. 20:2–3). Icons remind us that we are God's possession and God's beloved. Or, as Thomas Merton wrote: "We are all one, but we have forgotten. The task of religion, of all living is to once again make us One, to reveal that in our flesh, in our times and upon the earth." It is *the* task of the human race, as it was the task, the mission, and the Good News of the Messiah, the Word of God made flesh of the Virgin and dwelling until forever among us.

An icon is a talisman, a protective wooden scapular, a lifeline in the face of evil and bloodletting. It is a silent witness and an unsingable song of redemption proclaiming that we are blessed creatures, destined to become like God once again. These icons call us home, call us back to ourselves. Mary, the Mother of God, the mother of all the living, seeks to give birth to us as she gave birth to her firstborn child in the world. She calls to us in these icons as she called to her son so often on earth. Her child, the Son of Justice, Son of God, son of Mary, beckons to us, blesses us, and holds a mirror up to us so that we can see ourselves in the eye of God. And she is there, just there, watching over, protective, letting us go and waiting for us to return as she must have waited for Jesus the Crucified One to come on that first dawn of the resurrection.

The poet Rumi tells a story that we should consider before we contemplate these icons:

A friend of Joseph's went to visit him after returning from a journey. "What present have you brought me?" Joseph asked.

"What could I bring you," his friend replied, "that you don't already have?" "But," he added, "because you are so

beautiful, and nothing exists in all the world more beautiful than you, I have brought you a mirror, so you can know the joy at every moment of seeing your own face."

[Rumi comments:] Is there anything that God doesn't have already that you could give him? Is there anything that God could need that you could possibly provide? All that you are here for, and the entire meaning of the Path of Love, is to bring before God a heart bright as a mirror, so God can see His own face in it.

Mary, the Mother of God, was God's truest mirror. In these icons we can see ourselves in her eyes and know ourselves as her children, children of light who were called out of darkness into the glorious light and freedom of the children of God. The mirror is held up before us. Come, look at your face, your true face, and sit still and know God. Know God without a veil, in Jesus, face-to-face in a glimpse, a glance, of love. Hear deep in your soul the words of the Holy One: "Be still and know that I am God. I am your God and you are mine. All of you are mine" (Ps. 46:10).

My grandmother used to say: "God never takes his eyes off you, dear, because you are so dear to him." In these icons Mary, Mother of God, Mother of All Nations, smiles, never taking her eyes off us. Sit now, in the presence of the holy ones, and be seen through. Let these be the images engraved upon your heart. And "dare to see [your] soul at the White Heat" (Emily Dickinson). For as the gospel craves a listener, the icon craves a seer. And it is the seer, the seeker, who completes the icon as it pries us open and shares with us its silent, unspeakable language. Here the shining Body of God and the small exultation of the servant of God, Mary, Mother of God, fuse sight, give solace, diffuse sorrow, and carve these images into our own hearts. Here the Holy comes to inhabit us. This page is the threshold. Turn the page and see where silence reigns. Keep company with the holy ones of God. Pray. Here the chasm closes. We

are riveted to this refuge, this solidarity, this compassion that discloses itself and then encloses us.

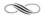

May the Son of God lean over us and take root in us. May the Spirit hover and the Father hold us dear. And may Mary, the Mother of God, bring us into the presence of this Trinity that seeks to kiss us again and again with glory and suffuse us with the hush that first was at the world's beginning. This blessing upon all who read what is written here. Amen. Amen. Alleluia.

1

The Shrine of St. Anne
(Anne, Myriam, Joshua)

Mary is Nazareth's faithful daughter, the ark of the covenant, the root of Jesse, and Joshua (Jesus), the word of the covenant, is born of these women. This is an unknown morning before the cold dawn of the Daystar, seated on Wisdom's chair. This is faith's ancient history, genealogy, going backward and forward in grace and time. This is the "house made of dawn." Like the dolls that Russian and Greek craftspeople have for centuries nested one inside another, here we can see one generation nested inside the other, layer upon layer of promise given to a people, of hope in each generation, and hope brought forth in the person of Jesus Christ, yesterday, today, and forever.

As the Christmas carol proclaims: "The hopes and fears of all the years is born of thee this night." This is our lineage, a branch of our family tree, through our mothers. Anne is known only in tradition, like so many other anonymous mothers. But Jesus, born of a woman betrothed to Joseph, is Jewish through his mother's line and blood ties, through her human flesh, though divine in promise and his Father's long-invisible love. These are the connections to all the women and men who sang the psalms with fervor, hoping firmly, never suspecting what was to come forth from their legacy of faith:

You have searched my heart,
You know when I sit and when I stand,
Your hand is upon me, protecting me from death,
Keeping me from harm.
You know my heart, you who have formed me before I
 was born.
In the secret of darkness, in my mother's womb,
You taught me wisdom, as my inheritance.
Darkness, sweet darkness, secret seed sown across
 generations.
How marvelous your works, from age to age!

<div align="right">(Psalm 138/139)</div>

This trinity blends the towering strength and wisdom of the Old Testament with the incarnated tender and mothering wisdom of the New Testament. The child is the seed, the fruit, and the core of the women's flesh and of all history. Though the women loom large, our eyes are drawn to the wombs, to the heart, to the child with the scroll in hand, to the Word of God that pitched its tent among us and dwells now in every place, in every person.

Daughters of God, who taught the words one to another across the years, teach your great-great-great-grandchildren now. Teach us how to pray, how to pass on the best of our tradition and faith to one another. We trace our roots back to your own, in covenant, in creation, and in the human community.

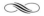

Seat of Wisdom, grandmother, daughter-mother,
 serpentine graces,
seeping through the ages with longing, passing on life,
teach us to see in every face both young and old,
the marvels of God being revealed in our times.
May we your children by redeeming grace be offspring
that surprise you with gladness as once your firstborn
 brought you unbounded joy.
Let us sing with you: O bless the Lord, my soul,
and all that is within me, bless your Holy Name.
Amen. Amen. Amen.

2

Mater Domini
(Mother of Our Lord)

*(From a thirteenth-century mosaic in the
Basilica of St. Paul Outside-the-Walls, Rome)*

"Who am I, that the mother of my Lord should come to me?" (Luke 1:43). Elizabeth's wonderment as the presence of God comes to visit her and Mary's greeting sounds in her ears, stirring even her child to recognition and joy, is the moment framed in this icon. Mary's voice uttering the ancient greeting "Shalom" (the peace of the Lord be with you) is like an electric current jolting John — the one who goes before the Lord — awake, alerting him to immediacy, to the nearness of the Word made flesh, sleeping and growing in Mary's flesh.

The Word of the Lord, in Gabriel's Good News, has come to this young woman and she is "good soil" — like those who "upon hearing the Word, hold it fast in their hearts and bring forth fruit with patient endurance" (Luke 8:15). She is an Israelite, one who waits on the Word of the Lord, staking her life on God's faithful promises. Like Abraham, she endures with her people, but now she knows God's time has come. And now every greeting, every word that comes forth from her mouth, is like dew on the ground, rain in a parched land, hope for dried up and shriveled hearts

27

that have so long sought the coming of the promise into their lives.

This child she bears with a gesture of presenting — of offering him to us — is the ancient Word: "Yahweh our justice" (Jer. 23:6), who will right the flawed universe and hearten the poor with justice. She gazes toward us — hopeful that we will hear the Word of Good News to the poor, release to the captives, recovery of sight to the blind, liberation for the oppressed, and a year of mercy from our God, who is Lord of all by right of justice's love. The child is mature, an expression of God triune, with a scroll in his hand.

She stands, as she will stand enduring and faithful to the Word at the foot of the cross. She looks at us knowingly — knowing in her own life and her long life as mother of all that only when injustice and violence are banished from the earth and justice and truth reign throughout the earth will Yahweh the Lord, her Lord, be known as Yahweh Shalom: "The Lord is peace" (Judg. 6:24).

The border is a mosaic of crosses, reminiscent of the early churches' persecution and martyrdom, the blood of those who were faithful in the face of death, of those who, although they loved life, did not shrink from handing it over (see Revelation) to be the seed of another Christian's life. The depths of Mary's blue mantle represent the depth of faith that the Lord has called us to practice in the world as surely as deep waters cover the earth.

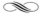

Mater Domini, mother of Our Lord,
plant and nourish the seed of God's great reversal
of fortunes in your children's hearts.
Make us strong and steadfast, a people of enduring
faithfulness
who hear the Word of the Lord and let it take root
in us.
May we be people of peace who know, with you,
that Our Lord is Yahweh Shalom, and this child
is the Lord of our hearts. Amen.

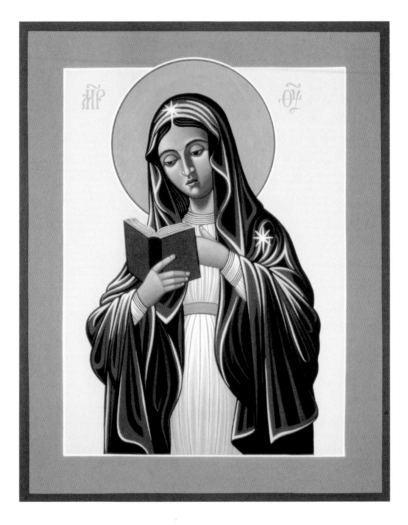

3

Mother of the Incarnate Word

Rabbi Abbahu said in the name of Rabbi Yahanan: "When the Holy One, blessed be he, gave the Torah, not a bird cried, not a fowl flew, not an ox bellowed, the angels did not fly, the seraphim did not say, Holy, Holy, Holy, the sea did not stir, the human creatures did not speak, but the world was still and silent, and the voice went forth: 'I am the Lord thy God'" (Exod. 20:2).

Silently, self-contained, this woman, in simplicity, studies the Word, taking it within herself, holding it dear. She is rapt and attentive, inwardly listening, obedient, receptive. The seed is planted; it matures and ripens within her. She will labor to give birth to the Word Incarnate, to freedom and liberation, to a great harvest of hope, to a field of peace a hundredfold — bread for the world.

The Book — opened, held in her hand, hand tracing the words, touching them as she touches the flesh of her child, newborn, growing in wisdom, age, and grace, leaving and slipping from her embrace the bloodied, lifeless body unnailed from wood in a touch that tore through her heart.

She is a contemplative. She knows, seeks truth, depth, and the light of understanding — "There is only Christ: he is everything and he is in everything" (Col. 3:11). She is treasuring all these things. This is the one Elizabeth spoke of who "is blest because she trusted that the Lord's words

to her would be fulfilled" (Luke 1:45). This is the woman who is the first disciple of the Son, one of the true kindred of Jesus, described in his own words: "My mother and my brother are those who hear the Word of God and act upon it" (Luke 8:21). Augustine writes: "It counted more for Mary to be the disciple of Christ, than to be the mother of Christ." Both Elizabeth and Jesus praise her for her belief in the Word. She is not only included in the group of his own disciples but used as the referent for belonging there (Luke 1:42, 45; 11:27–28). She is a believer. She is bent over the Book, as she bent before the Holy, the Word of the Father, and the Holy Spirit came upon her and the power of the Most High overshadowed her and the holy offspring that was born of her was the Son of God (Luke 1:35).

Our creeds tell us that the incarnation is a joint work of both the Spirit and this woman. Jesus is born of her flesh and God's breath. And again she is overshadowed by that power of the Spirit at Pentecost where she dwells in the heart of the community of the church as it grows with wisdom, age, and grace, as a fledgling (Acts 1:13–14; 2:1–4). Catherine of Siena writes:

O Mary, my tenderest love! In you is written the Word from whom we have the teaching of life. You are the tablet that sets this teaching before us. I see that this Word, once written in you, was never without the cross of holy desire. Even as He was conceived in you, desire to die for the salvation of humankind was grafted and bound into Him. This is why He had been made flesh.

Mary, write that Word, carve it deep in our hearts, and make us come true to God's will. Amen.

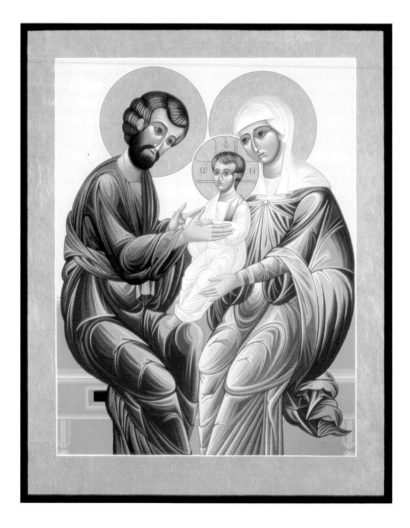

4

La Sagrada Familia
(The Holy Family)

Jesus is the center, the heart of this icon and this family, this relationship between Mary and Joseph. He sits lightly in Mary's hands, but his own hands rest playfully on Joseph's; his right fingers curl and clasp Joseph's thumb, as many young children do, and his foot rests on Joseph's knee. He is still wrapped or swaddled in newborn's clothes, a white garment with a border on his shoulder. Perhaps these are the clothes he wore when Mary and Joseph brought him to the temple to be offered as firstborn of this husband and wife to God, to do God's will.

Mary is graciously offering this child, her child, and God's own son, to be held in the sure arms of Joseph, who has taken them both into his home and his heart. He is the one who has adopted this child and raises him as his own, honoring the woman he loves with respect and care. All of their hands, bodies, and lives touch one another and are bound through the child, who is their bridge, their tie in love and responsibility to each other. There is wonder in Joseph's eyes; all their eyes are wide-open — indicating their hearts are laid bare before one another. There is a solemnity about their faces, a gravity that reveals some foreboding or intimation of what is to come.

They are a family, a trinity, man, woman, and child, but for those with eyes to see there is more: another Trinity lies hidden here, that of the Father, the Son, and the Spirit, *the* Holy Family, the community of God that is God. This small family lives in the embrace of the Trinity. That is what makes any family holy, any set of relationships holy.

They have presented the child to the Lord, according to their law and tradition, and it is this child who will present their lives to God as worship and sacrifice. Already we are told by the prophet Simeon in the Scriptures: "And this child is the light for revelation to the Gentiles and the glory for your people Israel" (Luke 2:32). Luke goes on to say, "The child's father and mother were amazed at what was said about him and Simeon blessed them" (Luke 2:33) — these parents and this family, called to be light in the sight of all peoples. And Mary is singled out and warned, told realistically, that she will suffer because of her child, this "sign of contradiction": "you yourself a sword will pierce — so that the thoughts of many hearts may be revealed" (Luke 2:35). The life of this family will find its meaning and its pain and its glory in the truth of who this child is, Son of God, Jesus, Word made flesh. This is the reality, the destiny of all families that desire to be holy, to see their meaning in this Word of God, and to share it with one another, letting it reveal their thoughts and lay bare their hearts before one another and before God.

And we are told that after the presentation of the child in the temple, they returned to Nazareth after fulfilling all the prescriptions of the law of the Lord, and "the child grew and became strong, filled with wisdom; and the favor of God was upon him" (Luke 2:39–40). Joseph, Mary his wife, and the

child entrusted to them go home. Together they grow up, grow in wisdom, age, and grace, being obedient to the will and law of God. They are strong together, sharing their faith, the Scriptures, psalms, and the words of the prophets, and the awe that fills their faces as the child is passed between them remains and characterizes their whole lives.

❧

Joseph and Mary and Jesus, your family was remarkable for your faithfulness, your trust in God, and your care for one another. Teach us, each of us, in whatever situations our families live, to follow in your way, to be together as light for others and as tightly bound to one another, in the Word of God made flesh, as you were on earth. May we hope to share in the glory of your family, the glory of all the kingdom of God, and the glory of those who have gone before us in faith and those who will come after us. Bind us together forever in your trinitarian love. Amen.

5

Mother of God Rejoicing, Pelagontissa

A woman swathed in purple, tinged with glory's gold and red lining. Her eyes so saddened, fearing, knowing: knowing prophets' passion and searing words and what retaliation is born of justice's proclamations. Yet the child is attired in white, braced with green's hope, and decorated with fleurs-de-lis and the Trinity's marks.

The child's hand holds up the mother's cheek, holding tears too deep to be shed. But the face is twisted out to look around, straight into our eyes — questioning, confronting, pointedly probing. Would you do this to this woman? Would you break this mother's heart? Would you share her seeds of sorrow? Would you let go your hold on hate and death? She knows the ancient prophecies. She contemplates their realities. She, who even now rejoices in life, remembers the original birth pangs, the terrible death pangs, the victorious tearing pangs of life opening the womb again, eyes again, prisons again.

Life and death provide such a jumble and tangle of limbs and loves and human beings, God's wonders, our evils, and death's claw — all weaving the rich purple of her mantle of rejoicing. There is no escaping history's claims, choices made, the twisting of the story's beginnings. But then again,

there is no escaping the love, the freedom, the rejoicing of her heart in her son's resurrection.

Daniel Berrigan has written a poem based on Isa. 42:1–7. It is called "In the Beginning":

> (In the beginning)
> all things left my hand.
> You, clay gently kneaded.
> Mouth to your mouth, a lover,
> I breathed,
> you breathed, newborn.
>
> Now hand in hand
> we walk the world.
>
> You, as though clean parchment —
> my covenant, your flesh
> writ. You, living text.
>
> My work, my wonders, yours;
> to open blind eyes
> to lead forth the captives!
>
> These, yes
> ever greater works, await!

Mother of God Rejoicing, now you invite us to walk the world with you. Give us your unshed tears, your faithfulness to God, your silent witness to God's original hope for all the earth. May our tangled and intertwined lives serve to set the world right and turn all its mourning into dancing. May we all come home together and gladden your heart and wipe all your tears away. Let us together with you magnify the Lord again. May all our spirits rejoice in God our Savior. Amen. Alleluia. Amen.

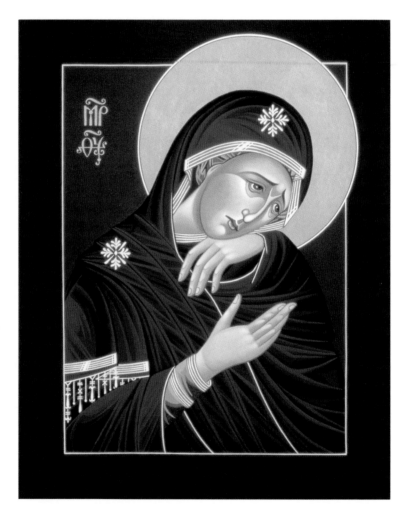

6

Nuestra Señora de los Dolores
(Our Lady of Sorrows)

This feast of Mary is celebrated on September 15, following the feast of the Exaltation of the Cross, and is traditionally the beginning of monastic Lent. Together with this woman of sorrows, we are called to meditate on the passion of Christ, the absence and the lingering presence of the Crucified One. In this woman's face and form there can be no other reality. Everything is subsumed into this sorrow: "Is any sorrow like unto my sorrow? Look at me! Listen to my heart beating. I am a witness, a solitude before death, before the death of my beloved, before God in our flesh, my flesh. I am alone before the attempt to destroy divinity. I know the horror of such evil."

This is a woman in extremity, her body stretched to hold spirit, to hold sorrow, to hold the human and divine inside her. This is the woman who knows intimately the old man Simeon's prophecy that was a knife in her soul, a sword in her heart. She knows that association with this child, who was a sign of contradiction, division, and contention, is dangerous. He was the cause of the rise and fall of many, and the sword cut home in her so that the secret thoughts of many would be revealed (Luke 2:34–35).

This is the woman wounded by division, by the wrenching

choices of those from his own hometown who rejected him and those who sought from the beginning to kill him by massacring even children. This is the weeping woman who nightly (it is told in stories) cried hot, silent tears with all the mothers whose hearts were torn from them as their children were torn to pieces by the soldiers. This is the woman whose soul was soaked in blood, the blood of her own beloved child grown to be a man of integrity, who was crucified on wood with grisly legal precision, executed by the state as dangerous to its idolatrous intentions.

This is the woman whose countenance has been carved by convulsive grief. All the life leaves through her eyes as she watches the blood seep from his rent and torn flesh. This is the woman of Lent, of Good Friday and all the days of death since, when she must stand at the foot of the cross, her arms awkwardly empty, helplessly gesturing toward all those who are her children — the murdered and the murderers.

This is the woman wrapped in the rich depths of night blood. She is the chalice emptied out. Her life and her mouth strain with silence, with obedience. She is disturbed deeply, not by an angel's presence but by the price her son endures to save his people from their sin. This is the woman who has carried the sorrow of our evil as she carried salvation's seed. This is the woman of sorrow, like her son, afflicted with our inequities (see Isaiah 53). This woman is beautiful beyond telling. She reveals in her eyes and face, her bent hand on her cheek, her other hand extended toward us, a glimpse of why God asked her to bear the cross in her body and why, in love, she said, "Yes."

O Mother, when you look like this, and hang suspended before us, you wordlessly remind us of all the horror we have done, of our sins' consequences. And yet, you hold us all in your inner gaze, in the deep tear in your heart, forgiving us, as you forgave those who nailed Jesus to the wood of the cross and those who just as surely nailed your own heart to it. Mater Dolorosa, Nuestra Señora de los Dolores, never stop looking at us, until we stand beside you and share your sorrow, and know the sword you carried in our own hearts. We ask this in the name of Jesus Christ, your son, and God's beloved son. Amen.

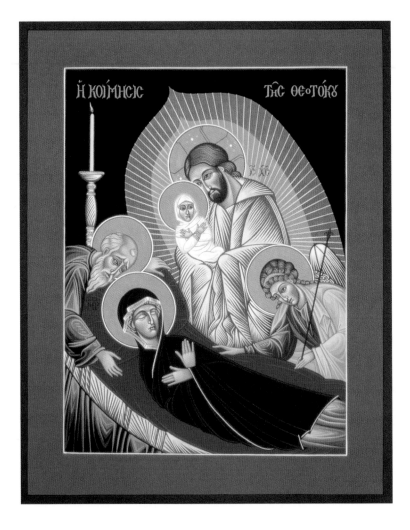

7

Dormition of the Mother of God

This is the great reversal of icons. She who gazes in utter devotion, who sees the flesh of her child and sees into the soul of her God, who contemplates the Word made through her flesh, whose sight destroys her very soul and rends her heart in crucifixion and death — no longer sees. Now she is seen. Now it is her son who sees and looks and holds his mother's soul, his disciple's soul — she who was first to "hear the Word of God and put it into practice." Jesus, the risen Lord, now holds the soul of Mary with learned tenderness. It is total reciprocity.

Jesus proclaimed for all to hear: "Everything has been entrusted to me by my Father. No one knows the Son except the Father, and no one knows the Father except the Son and those to whom the Son chooses to reveal him" (Matt. 11:27). Now, this woman is known, and she knows as her son knew God. He has given her life wildly beyond even the life she gave to God in handing over her body for God to use on earth.

Jesus here is mother, cradling the soul-child of Mary, wrapped in glorious swaddling cloths, her hands crossed over her breasts in the sign of belief, marked as God's in her inner flesh. Jesus leans protectively over her, in death and in life. The risen Christ, with hands buried in the folds of his garment, carries her into his kingdom. He bends toward her

lifeless, serene body, eyes and womb closed now in death. She lies in one seamless veil, her hands crossed over her body, belonging to her God alone, virgin-still. Christ protects her as she crosses the threshold from death into life.

This is the icon of innocence, of the purity of Mary, the wholehearted Mother of God revealed. And there are others bent over her. There are two who knew her at moments in her life, one from the beginning of her obedience and one at the moment when that obedience became a complete sacrifice of all she held dear in her child's death. There is Gabriel, archangel of annunciation, bending low before the one who obeyed even beyond an angel's inbred nature to obey. He honors her whose freedom liberated all of us. And encircling her head is the aging disciple John, leaning his head on the couch that bears her corpse as once he leaned on the breast of her son the night he was betrayed.

This is the inner soul of the crucifixion. As Jesus was dying, "He saw the Mother, and the disciple, and said to the Mother, 'Woman, this is your son'" (John 19:26). She who gave birth to the child of God and to the children of the church, who gave her life at the request of God, a message borne on angel's breath, and continued to give life to his friends, is now wrapped in resurrection's everlasting grasp. This is Christ presenting the soul of Mary to us, to see its glory. The Dormition — the sleep of the Virgin's soul, the Mother of God's soul, reveals the joy of God come to take his mother home.

Mother, you who never sleep, who are ever watchful
of your restless, struggling, and suffering children,
we look at you with awe.
Mother, you who know home to be the heart of God,
be with us,
now and at the hour of our deaths.
Be with us and give us of your serenity and peace, faith
and joy.
Whisper to our dying souls, "Today you will be with us
in paradise."
Come home, children, come home. Amen.

8

Mother of God, Mystical Rose

In the life of St. Gertrude the Great (1256–1302) devotion to Mary as the Mystical Rose flourished. Gertrude wrote this prayer in her honor:

Hail, White Lily of the ever-peaceful and glorious
 Trinity!
Hail, Vermilion Rose, the Delight of Heaven,
Of whom, the King of Heaven was born,
And by whose milk He was nourished!
Do thou forever feed our souls by the effusions of your
 divine influences. Amen.

This image of the Mystical Rose is both ancient and universally known. Rumi, a Muslim mystic-poet, wrote:

A man once asked me, "Is there a way into the Other Place here on earth?" I said, "Yes, there is a door between this room and the other. For every person its size is subtly different, for it has the shape each being makes when on their knees. No one enters the Rose Garden unless lost in adoration and wonder; no one walks through that door except on their knees."

You are — we all are — the beloved of the Beloved, and in every moment, in every event of your life, the Beloved is whispering to you everything you need to

hear and know. Who can ever explain this miracle? It simply is. Listen, and you will discover it every passing moment. Listen, and your whole life will become a conversation in thought and act between you and him, directly, wordlessly, now and always. It was to enjoy this conversation that you and I were created.

Mary too was created for this conversation. Long before Gabriel bent before her asking the favor of a reply to God's great desire to become one with us in her flesh and the body of her son, Jesus the Christ, Mary listened, tuned her ear and soul to every whisper of the Holy. She was one of the *anawim*, the lowly and poor who lived on the promises of God and waited for God to make them come true. John Paul II has written: "Mary gave full expression to the longing of the poor of Yahweh and is a radiant model for those who entrust themselves with all their hearts to the promises of God."

And this woman is radiant! Her skin glows like the heart of a fire, and her mantle is the deep red of blood that was shed in birthing, and in the blooming of her son's love as he died on the wood of the cross. Her lips are the color of roses that have known the hidden wine of contemplation and communion with God. This is Mary whose silence grasped the Word of God and allowed the Spirit to transfigure her body and soul, who allowed God to borrow her blood and bones and skin so that the conversation between God and all of us, his often deaf children, could be opened and begun anew. This strong face has listened to the gasps of loved ones suffering and dying, to the sighs of those rejected, persecuted, and ignored, but she has also listened through

the ages to the songs and glorious cries of those who bless God forever.

And we are allowed to overhear one of her mystical conversations in Luke's rendering of her Magnificat, when she carried the unopened flower of God's love within her:

> My soul proclaims the greatness of the Lord
> and my spirit rejoices in God my Savior
> because he looked upon the lowliness of his servant.
> Yes, from now onwards all generations will call me
> blessed,
> for the Almighty has done great things for me.
> Holy is his Name,
> and his faithful love extends age after age to those who
> fear him. (Luke 1:46–50)

O Mary, Mother of God, Mystical Rose, in your conversation with God you are always opening, just beginning to blossom and giving birth to the Word of God to anyone who will hear and take this Word of truth and love to heart. May we stand with you, side by side, arm in arm, before God and sing God's glory in us as once you stood on Galilee's hills and proclaimed God's mystical compassion taking root in your own flesh. Help us to remember that we were made for this conversation with God, with the friends of God, and, of course, with you. Teach us to speak, to be silent and listening, and to sing: my soul proclaims the greatness of the Lord and my spirit rejoices in God my Savior. Amen.

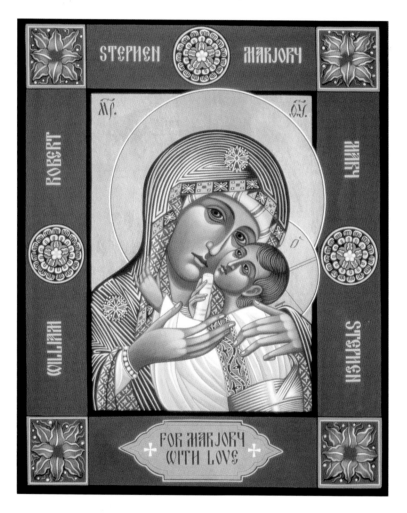

9

Mother of Fairest Love

I am the Mother of Fairest Love, of reverence, of knowl-
edge, and new hope; therefore I am given to all my
children. (Sir. 24:18)

Ah, a framed portrait, a Madonna and child — intricate, de-
tailed veil, dress, stole, garments of pure joy and ecstasy. The
rosy pinks of dawn and soft greens of spring's new growth
draw us to them. Hands and faces touching, caressing, rub-
bing cheeks as mothers and children do, as lovers and friends
do, as families do. A photograph, all golden, with rich em-
broideries of stars and flowers, a bit of the Garden of Eden
come to earth again! These are shining bodies, stars come
to touch the ground. This is a pure, clear word of love, and
it is mystery that sings silently in skin and relationships of
spirit and grace. This is what Spirit looks like when it seizes
physical flesh and embodies itself in humankind. It pulses
and beats, a heart exposed. It is alive in our hands as they
are in each other's arms. Here is contact that is electric.
Here is company, dwelling together. This is a secret world
uncovered — one that we can grow within, if invited in.

And "all this juice and all this joy" (Gerard Manley
Hopkins), all this drenching of the Divine, this essence of
intimacy, is bordered with names. The names of a family:
at the base, "For Marjory with love," the dedication to the

mother, deceptively simple words. Then up the sides and across the top, the siblings, brothers and sisters in blood and spirit: Stephen, Robert, William, Mary, Marjory, and the husband and father, Stephen. Namesakes, all for the sake of the Name — LOVE. It is the family, the bindings of the iconographer's own loved ones, but it is every family, woven of diverse threads into a shining garment of God.

This woman of fairest love is Wisdom described in the Scriptures. Listen: "She is a breath of the power of God, a pure emanation of the glory of the Almighty; she is a reflection of eternal light, a spotless mirror of God's action and an image of goodness. She enters holy souls, making them prophets and friends of God, for God loves only those who live with Wisdom" (Wisd. 7:25, 26, 27b).

This mother is a gift of God to all of us, calling us to imitate and experience in our relationships of love some taste of reverence, of knowledge, and of holy hope. In honoring the mother we honor the Son; in knowing the mother, we know the Son.

O Mother of Fairest Love teach us how to delight in those God has given us to love and those who love us. Help us to reverence them as gifts from God and to know the deep abiding indwelling of joy that is faithful and enduring and in rare moments exhilarating and beyond description. May we live as God intended and share the "fullness of God that we have all received, love following upon love" (John 1:16).

Let us remember that we are all children of your beloved son and are given to share of the delicious wine of the one family of God with you as our mother. Dwell in our families, bringing your light and breath, and make us all the friends of God. We ask this in the name of our God, Father, Son, and Spirit. Amen.

10

Madonna della Strada
(Madonna of the Way)

This is the woman who first walked the way in Jesus' company, as later others, like the first disciples called in Galilee, would "go off in his company" (Mark 1:18), following him, following the Father's way. Always, those who hear the Word, who are attuned to the Scriptures and learn to incorporate the Word into their own flesh, go off together and live in the company of others searching out wisdom, sharing common life, and supporting one another on this way. It is the way of truth and mercy, the way of justice, the way of "denying your very self, picking up your cross and coming after Me" (Mark 8:34). It is the way of picking up the burden laid on those who suffer without cause the grievances of those who do evil.

It is her way, too, from the beginning when she answered Gabriel: "May your way have its way in me, in my person, in my life. May your will come into the world through me. I am your way into the weary waiting world that has been so half-hearted in following you, the world where prophets stumble and the poor drag along, where saints and sinners grow together. Come, this way is open wide to your Word."

This Madonna, this street-wise woman, knows the way. She treads the streets, byways, back alleys, highways, know-

ing they all belong to God now and all can lead home. Her child, hand raised in guidance, in direction, in teaching, salutes all those who will come after him — from Peter, James, John, Mary, Martha, Lazarus, Susanna, through Ignatius and company, to Dorothy in New York, and Thomas on the corner in Louisville, all the street-savvy folk of the gospel.

This is clear, as clear as both mother and child gazing out at strangers, passersby, friends, fellow travelers, gypsies, immigrants, those looking for sanctuary. The wise child holds the Book and wears the red of sacrifice freely given over. The wise woman holds the child of her flesh, of the Father's passion, and of the Spirit's insight. Together they stand out accosting us, on our way. They invite us. Come, walk with us now. Come, follow us on the way. Come now, don't you know "that for all who believe, all the way home to heaven is heaven" (Catherine of Siena)? The ancient psalm reminds us:

> They go out, go out full of tears,
> Carrying seed for the sowing.
> They come back, full of song,
> carrying their sheaves. (126:5–6)

Where are we bound, carrying this Word entrusted to us, as company on our way? Is this Word hope for all those we meet along the way? Do our company and our greetings invite the world into the presence of God? Does our way cross through the byways and highways where we bring Good News? Are we bound for glory?

Madonna della Strada, help us to embrace the way of your son, the way of God's Word, the will of God even unto the way of the cross. Thus may we walk until we are met on the way of freedom and resurrection by Jesus the Christ walking toward us, wanting our company forever. Amen.

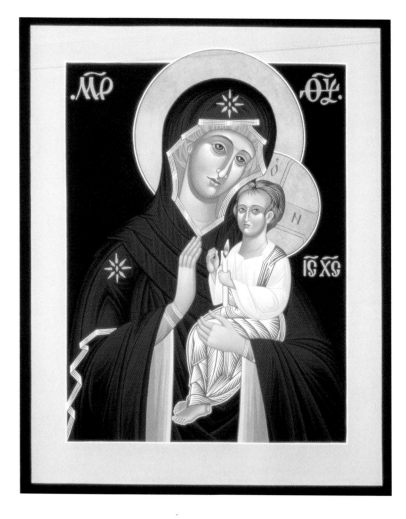

11

Mother of God, Light in All Darkness

This icon was commissioned by the National Catholic AIDS Network to offer protection and strength as people gather to keep the flame of hope for a cure and for acceptance alive during long years of struggle.

It is an icon of three candles. This vulnerable child holds and shields one candle flame with his small hand, and the mother shields the light with her own protecting hand that is also raised in blessing. She is wrapped in deep passion, deep fire, deep blood, deep royal garments, and is full of sorrow. Both child and mother are flames against the dark of night, the dread nightmares of our times, the nights of despair and persecution of those condemned by others. They are a trinity, a community sharing bonds of pain and brightness.

Their faces glow, with deeper light within, the light that shattered sin and death, the light that entered the world, the light that no darkness can overcome (John 1:5). She is bright mother, and her child is the light of the world. They hold us, called in baptism to be candles of comfort and consolation to one another in our pain shared. We have been summoned to bring that light unbroken to the world and to our own deaths — until our lights burn out, impassioned, and come to be one fire in God's great heart.

These are our companions on the way who remind us of the dream. In our times of physical pain, isolation, and trembling fear they will be our healers. In our times of separation from God and one another, they are our communion — a warmth of presence, as darkness gathers around us. But nothing can extinguish this inner burning. The mother and child are given to us as shelter, as a silent blessing on all those who must depend on God, and especially on those who find their sickness and grief, and their time on earth, too much to bear. We are surrounded with and encircled with love, the love of mother and child, the most vulnerable of loves and the most sure of loves. This is an icon of community, a shining image of what we are to be in the world that all too often lets the light go out. We are given to one another, as they are given to each other and us, to be a wall against the winds of hate and ignorance, against the fury of pain, and against the icy stares and long neglect that assail so many who are sick with AIDS but further afflicted with others' utter hard-heartedness and lack of compassion. In hope this mother and child proclaim that those we neglect are held in the hand of God's child and blessings hover nearby.

Mother of God, Light in All Darkness,
free us from the shadows of sin and death.
Hold our very lives, our bodies and souls, close to your
hearts
until we see the light of salvation and God's glory
shining upon us forever.
Until then may we imitate your protective attention
and bend
with care over those whose wicks are short and frayed
and whose spirits are bent and bruised.
We ask this as children of the light. Amen.

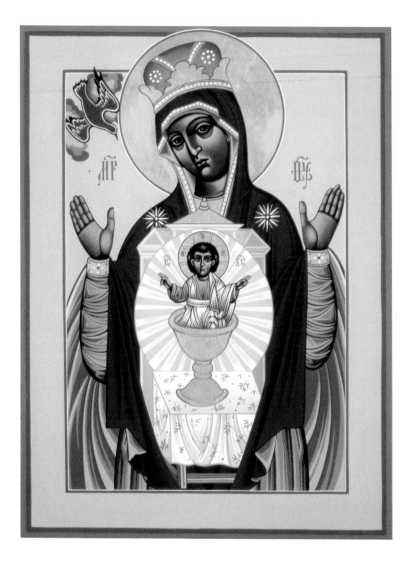

12

Black Madonna, Your Lap Has Become the Holy Table

Bright mother, dark virgin, you stand with hands raised in prayer, offering praise, making sacrifice. You stand before the altar; you are the altar, a table spread with the feast of your son. You are the new temple; your body holds the body of Christ, the church, the child, the priest-victim, and the offering of thanksgiving, Eucharist. It is God who has vested you with joy. You gently expose your heart and reveal where you dwell.

> In verdant pastures where God would give us
> repose, . . .
> you spread the table before us. . . .
> Our cup overflows. . . .
> Only goodness and kindness
> will follow us all the days of our life;
> and we shall dwell in the house of the Lord
> for years to come. (Psalm 23)

You are the compassionate Black Madonna, beautiful and comely (see the Song of Songs). You carry compassion to us and open your arms wide revealing *rechamin* (literally "movements of the womb"), God's mercy (Exodus 34). Like Moses,

you have seen God and your face is radiant, unveiled. The ancient prayer rings true! The Byzantine liturgy of St. Basil proclaims:

> O you who are full of grace, all creation rejoices in
>> you!
> The hierarchies of the angels and the race of humans
>> rejoice.
> O sanctified temple and rational paradise, virginal
>> glory, of whom God took flesh!
> He who is God before all ages, became a child.
> Your womb he made His Throne,
> and your lap He made greater than the heavens.
> Indeed all creation exults in you.
> Glory be to you!

The Spirit clothed in fire hovers over you as you reveal your son, the wine of justice, the cup of salvation, the offering of peace. Your red robes and veil are vestments of martyr, priest, and holy Madonna. This is the Spirit's sacrifice — given to the Father for us to drink and share. We too stand, hands raised in adoration of God, made of your flesh, the Spirit's breath, and the Father's love. The poet Rumi writes:

> How is Spirit sacrificed to become Breath,
> One scent of which is potent enough to make Mary
>> pregnant?
> Every single atom is drunk on this Perfection and runs
>> towards It.
> And what does this running secretly say but
> "Glory be to God!"

Black Madonna, you invite us to the table, to intimacy and feasting with God and one another. May we sit together around your son and drink the cup of blessing until we drink it with great joy in the kingdom of God. This blessing cup is the communion in the blood of Christ. As we raise this cup to toast our God's goodness may our own bodies become a fitting and pure sacrifice for making the world holy. We ask this in the name of the Father, the Son, and the Holy Spirit. Amen.

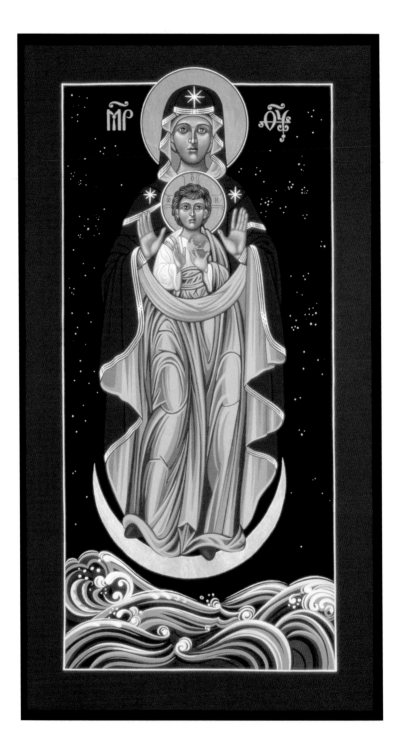

13

Ave Maris Stella
(Hail Star of the Sea)

This ancient greeting, calling to this guiding star, this bea-
con that beckons toward home! Mariners, seafarers of old,
called a compass "star of the sea" because of its shape. "Is
Our Lady the true compass of the Christian life?" (Dame
Felicitas of Stanbrook Abbey). The dark of night falls back
as Mary and her child emerge in this common brightness,
boldly advancing toward us.

All elements of creation — light, dark, water, sky, moon,
stars, space, and human flesh — are in harmony. She stands
firmly on a sliver of moon, navigating a course through tur-
bulent waters with ease. Hands wide-open, blessing, and
moving forward toward us — like the prow of a seaworthy
vessel. Eyes wide-open, parting our hearts, intent on en-
tering into our troubled souls and storm-filled lives, during
this dangerous gale-battered journey. Blue of water and blue
gown know each other. She's walked those waters herself
and wears them draped lightly on her limbs now. She hears
the murmurs of broken hearts, those who mourn the death
of loved ones and who know the tides of despair and the
panic of exiles and refugees. And her spirit steals softly over
us with calm.

Her child, the Word of God, leans up against her, sure

of her strength, backbone, and the ship's ribbing. He holds the world, continents and seas of green and blue, echoes of their own garments, small enough to be a child's toy, a ball held in a cupped hand. This is the child of the mother! Compass steady, four directions holding true, all radiating from one point — the heart-womb of a woman's word — the way to steer home by. This is the mother of the child! Holding the balm of the world, a treasure safe in a pocket, comfort cradled in her cloak, held close to a heart that first took him to her heart in an overflow of love. He is graceful, slung across her lap, as she is rocked on the moon's curve.

And the stars — the stars behind them are faint twinkling lights in comparison to the stars that mark her forehead and shoulders in the sign of Father, Son, and Spirit. Even their eyes seem to be stars bright in the night! There is no mistaking the original goodness of God's wording of the universe and all that it holds. Hugo Rahner, S.J., has written:

> The world was not created under some kind of constraint; rather, it was felt, it was born of a wise liberty, of the gay spontaneity of God's mind; in a word, it came from the hand of a child.

Ave Maris Stella, the waters of baptism have closed
over us,
and we have come up gasping for the fresh air of God's
Spirit.
Grasp us by the hand, dear lady,
whose waters broke to loose a Savior into the world.
Ave Maris Stella, Ave mother of our maker, Ave
compass of our souls,
make us bold in our belief, playful in our hope,
and boundless as the sea of God's love you have so
openhandedly brought to earth.

> *Mater amabili, ora pro nobis,*
> pray for your children who call upon thee.
> *Ave sanctissima,* star of the sea. Amen.

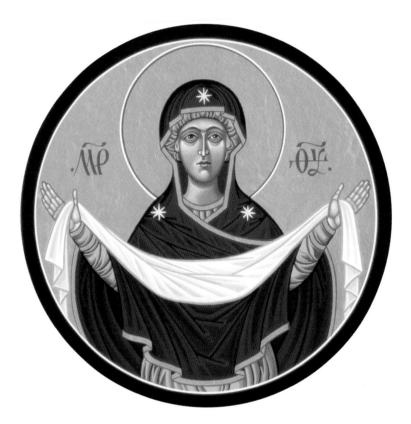

14

The Holy Protection of the Mother of God

This icon has been revered since ancient times by Greek and Russian Orthodox churches. During a time of terrible danger, a Greek saint and "holy fool," Andrew, and his follower, Eiphanion, were praying in an all-night vigil in a church in Constantinople for deliverance from an invading Slavic army. Suddenly the Mother of God and a great host of heavenly beings appeared in the church above the two. The Blessed Mother held out her veil as a sign to all Christians of her love and protection.

She stands alone, arms raised in prayer, supplication — of God and of us — to stop the killing, the great harm we do to one another, all the while claiming to be her children, forgetting that she is the mother of all peoples. She stands with the cloth draped across her arms as we drape the cross during the Easter season to remind us of the terrible price of resurrection. She is the sign of the cross's power to stop death.

She is solemn and heartbroken — Who can evade those eyes that silently tell us the truth about ourselves while her face reveals what we do to her heart? Her inner white veil of pure devotion, of unbounded love, is extended to us — she seeks to wrap us as once she wrapped her child in swad-

dling cloths and laid him tenderly in a manger. But those cloths were intimations of others to come — the shrouds that would wrap his body for burial. Her little child, grown to be a man of peace, would be butchered and brutally murdered, publicly humiliated, tortured, and pierced through in hate — all legally and self-righteously.

We have not learned. We still go after one another like dogs chewing on flesh and bones. In her sorrow she is always there, where there are battlefields and killing grounds. And her veil is first offered to the victims — beyond nationality or ethnic grouping, beyond race or religion. Her protection, her veil of tears, is for the ones we call enemy, those we treat inhumanly, the ones we massacre in our cruelty, as once her own son was stripped of dignity at the cross and killed. She stands centered, the eye of the storm, begging us to stop, wanting to enfold us with her veil and hold us all together — victims and killers becoming her children again in response to her son's victory over death. She prays to bring us back to life, to imitate her in opening our arms to clasp one another in forgiveness. She is an ambassador for God, pleading for us to be reconciled to one another in God. The Holy Protection Troparion, October 1, proclaims:

Today, believing people, let us radiantly feast,
Overshadowed by your coming, O Mother of God,
And beholding your most pure image,
Let us say with tender feeling:
Cover us with your Holy Protection,
And save us from every evil,
You who pray to your son,
Christ our God, to save our souls. Amen.

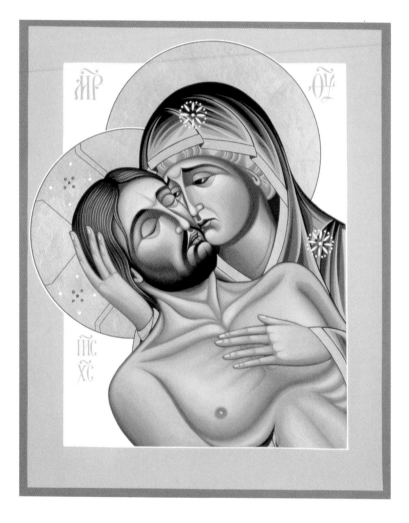

15

Mother of God of Magadan

Magadan is a city in eastern Siberia, built by Stalin as the administrative center of the slave labor camps of the former Soviet Union. It is a place of death where millions were martyred: holy ones of the Catholic and Orthodox traditions, especially three hundred Russian Orthodox bishops who refused to submit. The *perestroika* of unity, of communion of the Eastern and Western traditions of Catholicism, began here. The Soviet Union was once called "Holy Russia"; if it is to be so again, it will be in part because of the blood of so many anonymous souls harvested here. Magadan is a field of wheat, pale gold and rippling in the dying sun's heat. Magadan is the body of Christ rising.

There is such grief here, yet such love. Such sadness, such complete sacrifice of both the Son and the mother, of both the body and the one who shared her own body to give him human flesh. She holds the man handed over, grasped at by evil's grip and torn from life, yet she also holds the grown man as carefully as the newborn once given into the care of her heart to mother, to nurture, to wean, and to watch grow strong and true.

In John's rendition of the crucifixion she is given again a child grown — not only young John but the new family of God, drawn from the side of this man, the body of Christ. She is given the whole church. She is touching the body

before burial, before seeding his body to the ground that will not be able to contain it. She holds the empty cup of Jesus, drained of life and blood. She too has drained it to its dregs. And now she is invited to take into her arms all the bodies of those who died unjustly, brutishly in slave labor camps, oppressed and made to bear the heavy burden of oppression (see Exodus 1).

Her body holding his is altar and table where "from East to West a perfect offering may be made to the glory of his name," where all may share in the body made the bread of life, "life ever more abundantly for all." The suffering is "finished," yet it is not ended. The kingdom of communion among all those who confess to the Word of everlasting life is yet to resound throughout the world in exaltation. The cries call out from the depths of silent suffering, and so many still scream through the spaces and places of earth that have re-ceived the bodies offered up on the altars of the world's idols. There is still such vast pain, so many millions slaughtered one by one by one. Martin Luther King Jr. stated:

> Returning violence for violence only multiplies vio-lence, adding deeper darkness to a night already devoid of stars. Darkness cannot drive out darkness; only light can do that. Hate cannot drive out hate; only love can do that. Only love.

O Mother of God, dear Mother of Magadan, Mother of Holy Russia, mother of all those disappeared, enslaved, forced into hard labor, mother of those who like your son refused to bend before any god but the God of Life, the God most holy and transcendent, hold us as you have held your flesh in God's body and help us to hold fast to a singlehearted devotion to life, even unto death, and unto life without end. We ask this and sign ourselves in the name of the Father, the Son, and the Spirit. Amen.

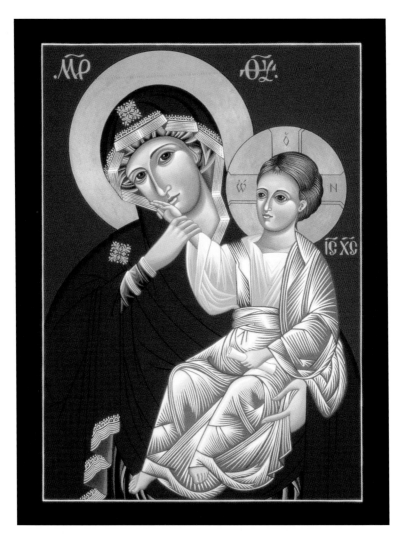

16

Mother of God of Vatopedi (Mt. Athos), Mother of Consolation

To "con-sole" — to be alone with, so singularly one, yet giving to another, with the other so completely in a gesture that signifies communion.

Mother with child, child with the one who bore him. This is Emmanuel, our God-with-us. They are together as they would be with each of us.

Look! This is the Trinity. The marks on her head and shoulder announce their presence. And she bears the visible God on her right. She is the Theotokos, the one who bears God into the world with all the passion that this child will bear on the cross.

Look! Let desire deepen, grow to an ache within. Let such gracefulness seep into your soul. This is God's intent in incarnation. This is God's hope for all humankind — to draw so near, to be so human, so close, so free.

This is a glimpse of God needing us in his great love for us in Jesus. As he reaches for her face, he reaches for ours. As she kisses his fingers, she would grasp our hands and kiss us with kindness — if only we, all of us, each in our loneliness, need, and isolation, could learn such consolation

and compassion for one another. Here, contemplating such human divinity and such a woman's love for her God; here in the presence of such beauty, we can learn, we can become apprentices of consolation.

The child's gesture, his hand brushing, caressing her cheek, the mother firmly holding his hand with fingers bent in blessing — these reveal them both as mother and child and as two knowing persons clasping each other in obedience to God's will. Their eyes are wide, contemplating us. They look at us together as one, with compassion. This is compassion as rich as the garments they wear. Hers is brown like earth itself and golden with light bathing her skin, eyes, hair, and hands.

The child, so mature, is arrayed in the palest of blues, almost white, and earth laced with light. So human, this God-with-us, with us in flesh, feeling, and the need for tender regard and love. Here is the need for touch, the need for closeness, for relationship. This is God so close, so inviting and warm, so alluring. It is sheer beauty that would share this embrace with us — all of us, each of us.

The Christ-child's hand clasps a scroll as his mother clasps his hand. What scroll is this, what writing is found within? Let us pray from the liturgy of Little Compline a portion of the Akathist hymn.

Glory to the Father, and to the Son, and to the Holy
 Spirit:
The ends of the earth do praise and bless you:
Hail, pure Maiden, Holy Scroll on which
The Finger of God did inscribe His Word.
Implore Him now, O Theotokos,
To write down your servants in the Book of Life,
Now and ever, and unto ages of ages. Amen.

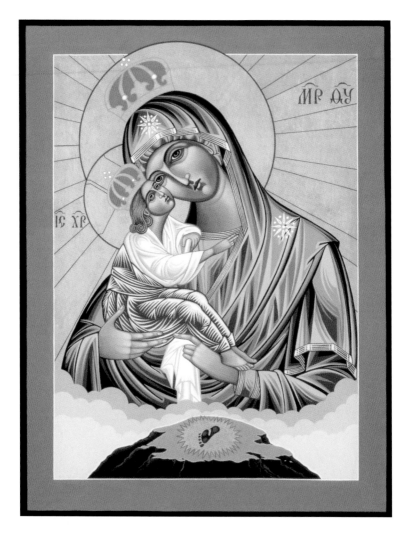

17

Mother of God, Our Lady of Pochaev

John Bird has written about the miraculous icon of Pochaev:

> It is said that on 17 April 1198 a monk went as usual to pray on the top of the Mount of Pochaev. Suddenly a pillar of fire appeared. Some shepherds saw it as well and joined the monk in prayer. When the flame had died down they saw the Blessed Mother on the mount. When the apparition disappeared the imprint of her right foot had been left embedded in the rock. A spring welled up over this footprint. The Mount of Pochaev, which is part of the Carpathian Mountains, is a place of natural beauty and for many centuries had visitors, pilgrims and monks in residence. It is thought that the word Pochaev comes from the old Slavic word, *chaity*, which means "to hope, to expect."

Mountains have always been places of revelation, places that are in-between, touching the realms of earth and of heaven, liminal thresholds. These are places where worlds overlap and leave traces behind. This lady is bound to the ground, to a place on earth. She once lived in another unknown small village, Nazareth, in occupied Roman territory. It was the first place God's feet touched the earth in the man Jesus. Together they appear here, crowned as queen and prince of all the earth.

From nowhere to everywhere, they reign in holiness and peace. Mary is marked with two stars, the presence of the Father and the Spirit, holding the third person of the Trinity, Jesus Christ, against her left shoulder. She is dressed in royal purple but also in gentle garments of justice and mercy, green and gold. She holds not only the child but, in her right hand, a white cloth. Is it for catching tears? Is it for cleansing faces and hands? Is it for wiping grime or blood and sweat away?

The child holds a rolled scroll, hidden words on white paper. Mother and child are so close, face-to-face, leaning into one another yet utterly careful in their touch. Their being together is full of grace. This is an icon of meeting: mother and child, queen and prince, disciple and teacher. But there are more meetings: between heaven and earth, human and divine. This is the psalm made visible:

> Mercy and faithfulness have met,
> Justice and peace have embraced,
> Faithfulness shall spring from earth,
> And justice look down from above.

> (Ps. 85:10–11)

There is deep joy here, and the footprint is the visible memory of God's walking on earth and the lady walking on Mount Pochaev. The icon tells us that every visit or epiphany of the Holy leaves traces of love, however faint, behind, for all to see. It proclaims that the kingdom of God has come to earth and it lives here. Look for its traces everywhere!

Mother of God, Our Lady of Pochaev, may we know you and your son's presence in our lives. May our feet leave God's trace of love wherever we walk so that earth's far reaches will marvel at God's visit in the presence of justice, mercy, and peace. May God's kingdom come, on earth as it is in heaven. Amen.

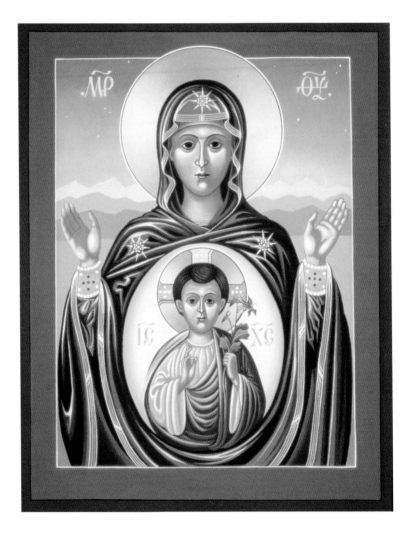

18

Our Lady of the New Advent, the Gate of Heaven

In the distance are the mountains, the Rockies of Colorado, snowy peaks stretching as horizon. From whence comes our help! And from whence has come Good News! She who brings forth God presents her child to us. She stands open before us, her arms lifted in prayer and revelation. She brings peace. Her gaze is calming and forthright. Her robes are simple. The child borne, the child to be born, is contained within her body. She holds him as a monstrance holds a Host, inviting our gaze. She holds him as the heavens hold the sun with quiet dignity and unassuming power and grace.

She is the gate of heaven. She is the threshold, the doorway between heaven and earth, between the presence of God invisible and God visible who comes to us as one of us, "like us in all things, save sin" (Eucharistic Prayer 3). The door is flung open wide, and the invitation is wordlessly sounded: Come! "Come, you whom my Father has blessed, take as your heritage the kingdom prepared for you since the foundation of the world" (Matt. 25:34).

Here is the gentle king who comes to us bearing a scepter, the flowers of the columbine, and with his other hand raised in a gesture of teaching, an expression of oneness, of Trinity, of wholeness and the fullness of time. Just as the Child

holds the columbine flowers tightly in his hand, he holds the students of Columbine gently in his heart.

She is the sunset gate of heaven. The daylight has faded, the stars come out. The years of one millennium have come to an end. She is the threshold between that millennium and the infancy of the present one. John Paul II called the last decade of the twentieth century the "New Advent" and prayed that this third millennium of Christianity be a new era of faith. But it must be more than that. It must be a thousand years of peace and nonviolence, for in just this past one hundred years we have experienced the bloodiest and cruelest time in the world's history. Since 1900 the world killed and slaughtered more people than had been killed since the beginning of time. This faith must be as solid as the mountains and as enduring and commanding in its presence among others. But it must also be like this woman's faith: resolute, unwavering, contemplative, born of acceptance of and reflection on the long telling of the Word of God in her people's history. It must be a faith seeded in promise and hope, the faith of the prophets and the poor, the faith of the lowly people summoned from the beginning to the feast of freedom, of liberation and joy, and with her son's coming in the incarnation, to the table of the Eucharist.

Lady of the New Advent, come! Come into our world and remain as it initiates the century that begins with 2000. Come into our history with your "Yes" to God's will and with your child who was "obedient even unto death, death on a cross" (Phil. 2:8). Come into our church and show us how to be open to the Spirit as the angel announced to you the words, "The Holy Spirit will come upon you and the power of the Most High will cover you with its shadow. And so the child will be holy and will be called Son of God" (Luke 1:35). Come among us again, in freshness and creativity, with grace and truth, with wisdom and obedience. Come to the poor and the lowly, to those in immediate need of justice and mercy. Come silently. Come singing the glories of God. Come with your greeting of peace: shalom. Come, let us stand before you and your child, our brother Jesus the Lord, at the gate of this new time on earth. May it be a time of coming true, a time of coming to grips with the sin of the world in the work of atonement, restitution, and restoration. May it be a time of coming home, to one another and to God, as faithful servants, faithful friends, and the faithful family of our God. May God, the Father, the Son, and the Holy Spirit, be blessed in this time. *Maranatha!* Come! Amen.

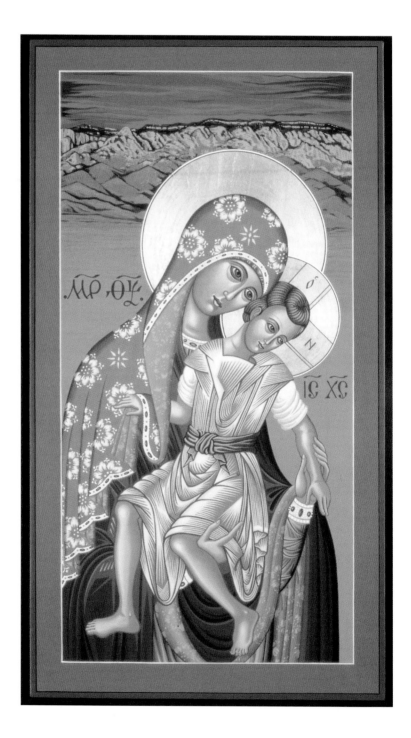

19

Nuestra Señora de las Sandias
(Our Lady of the Sandia Mountains)

The mountains reflect the dying light of the departing sun, turning rock to warmth, bathing stone with tones of live flesh and blood. They gleam with holy fire, the glance of God, the Son of Justice as the promise of resurrection and eternal dawn of life undying. The blood of the cross has seeped into the ground and is reflected in earth's own anguished longing for the fullness of redemption. The old New Mexico Spanish say that the word *sandias* means "fiery at night."

The Mother of God — the Theotokos — and Christ Emmanuel look down upon us from the sacred mountains, awaiting our climb, our joining with them in communion of peace. Their heads touch, her hand on his arm, carried so lightly — this child who grew in wisdom, age, and grace before all, revealing the holiness of God endlessly though never repetitively, as the Jewish sages say, like daily sunrises and sunsets. Such infinite love, such a sense of tender regard for all of us below, living on earth. She is festively mantled with stars and flowers, the soft pinks and roses in their garments and skin. Yet earth's green fecundity lines her veil. This is hope enfleshed and love displayed — invitation for those who have eyes to see.

And this hope is needed here. For these Sandias have vio-

lent faces too, though today they are mercifully dusted with
the healing powder of snow. The woman and her child sing:
remember many waters and fires cannot quench or extin-
guish love. Love is Rock-sure, permanent, from which our
help comes. They are cloaked in silence, looking soft as skin.

But see, too, near the Sandias — the frightened hills'
"wombs" are laced with nuclear death seeded with the
bleached bones of the apocalyptic horsemen. Look again and
see how the lady and the holy child turn to us, ache for us,
so torn asunder, so given to destruction, without trust. They
look to us for the truth and turning toward one another.

In the writing of this icon, we forgive with all our hearts
and tell the greater truth: that this holy pair are forever
bending in an arc of protection, a new covenant rainbow
over all of us whom God seeks to call "my friends."

∞

Nuestra Señora de las Sandias, kiss us with holy joy and the soft fires of purification. As the dying sun kisses the mountains' face and transforms the hills into silently singing psalms of creation, transform us into true peacemakers, the children of God. Amen.

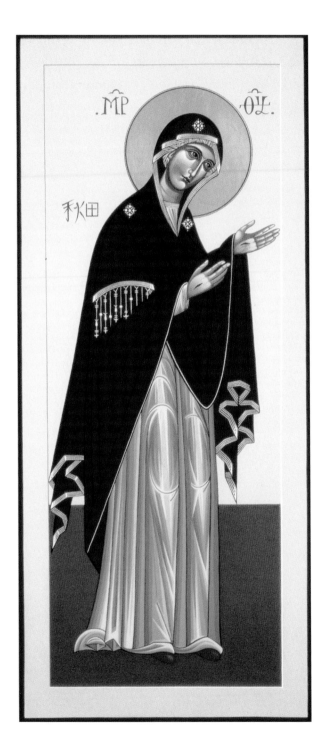

20

The Intercession of the Mother of God of Akita

Akita is a city about an hour's flight north of Tokyo. The word "Akita" has two Japanese characters, which are written over Mary's right shoulder. Japanese characters are pictograms. The first character (in two parts) represents the fall harvest, and the second represents a field. Outside Tokyo is a retreat house with a wooden statue of Mary, carved in 1963 by Saburo Wakasa. In the early 1980s the statue wept 101 times and also bled from the hand. This phenomenon of weeping statues, or icons, has a revered history in the Orthodox tradition. It signifies the desire of Mary to console those who suffer and are victims of the sin of others and to console her own son, who continues to be crucified in the injustices, evil, and sin of the world.

This woman, the Mother of God, stands inclined toward us, her arms outstretched. It is as though she stands beside an unseen crucifixion, standing witness to what we do not see. She is silent, as she was at the foot of the cross of her son. Her mantle and veil are one piece, the color of human blood. It is plain, with only a simple border and fringe as it drapes her shoulders. What is startling are her hands. They reach out in a gesture of prayer, of liturgy, as a priest's hands are extended from under the vestments worn at the altar.

Her hands bear the marks of the cross — the imprint of the nails, the skin torn open, the wounds still fresh with blood. She is marked by the death of her child, Jesus the Christ. She is a standing cross.

Her very stance is a statement of terrible pain borne with great dignity. The wide-open eyes and her face turned toward any who would look into her eyes reveal that she is also a question mark. She is a stabbing reminder, a gentle one, of what we have done to her, the mother of our God, of what we have done to her son, and of what we have done and still do to one another, to all her children. And so she prays for us and intercedes on behalf of all who are condemned to death and suffering by the will and decree of another. She has known through thousands of years the harvest of pain, the fields of those who die, the seed planted in the ground to bring forth life, the fire of yearning, and the desire for all of us to be one with each other and with God. She is the harvest, the field, and the fire of God.

And she intercedes with us. She stands before us, bent very slightly, as is the custom of the Orient, to bow before the other's presence, as preface to asking a favor. She is begging us, pleading for us, entreating us, to STOP: to look at what we do and what we have become in contrast to what we were called to be — the beloved children of God, the children of the Crucified One who laid down his life that we might live.

With her outstretched hands she seeks to embrace us, touch us as a mother, as a friend, as a woman of God's will and holy desires. She invites us to stand with her, to stand beside her, to stand together, and to pray with her for the aching earth. We can respond to her, as St. Francis did:

Hail, holy lady, most holy queen,
Mary Mother of God ever virgin;
Chosen by the most holy Father in heaven,
Consecrated by him, with his most holy, beloved son
And the Holy Spirit, the comforter.
On you descended, and in you still remains,
All fullness of grace. . . .
You, by the grace and inspiration of the Holy Spirit,
Pour into the hearts of the faithful,
So that faithless no longer,
We may be made faithful servants of God.

But, even more, she implores us to entreat one another to look at our violence, to see and stand beside those who suffer, to bear in our own bodies the marks of our baptism, the brand marks of those bound to her son, those bound to uncrucify and to lift up and give solace to those destroyed by sin. She would have us stand and pray with her:

I am your servant, God, I come. We come to do your will and to bring life. Amen.

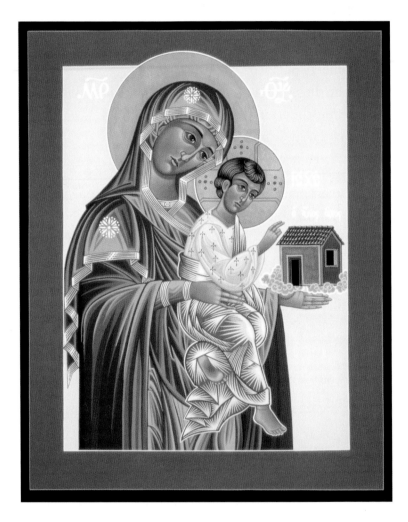

21

Our Lady of Loreto

We look here upon a woman holding a child, holding a house on a cloud. An unusual trinity. The house is a simple dwelling, with a door, a window, four walls, and a roof. But in reality this is an icon of three houses: Mary, household of the Word; Jesus, the tent pitched among us; and the house of Loreto. But this last house is every human being's soul, where our bodies dwell and where God holds us in his hand. Here, though, the lady holds the house in her hand, along with her child.

The woman's garments are beautiful, the color of dawn's rosy glow, or the high color in children's cheeks, or the reds and ochres of adobe walls, the dwellings of many desert peoples. Here is a house made of earth and morning. She is star-marked, a woman of the Father and the Spirit. This is the family of God named Trinity, and all households are invited and brought into one communion.

This is Jesus' last prayer: "May they all be one as you Father are in me and I am in you. May they be one in us; so the world may believe that you have sent me. I have given them the Glory you have given me, that they may be one as we are one; I in them and you in me" (John 17:21–22). This icon is a glimpse of Jesus' prayer before his death, while in the upper room of a borrowed house.

From ancient times there has always been the heartfelt

hope that each man and woman would be able to dwell in peace, that all would be able to sit beneath their own fig trees and drink wine from their own vines, and that there would be no war, no destruction, in all the land. And Jesus' kingdom is described as a blessed place where all the birds of the air, the unnumbered scores of sparrows, ravens, and crows, can find shelter in the branches and arms of the mustard tree, grown and spreading out into a canopy and dwelling place secure for all in need of a home. A home on earth, a home in God, a home forever — this is the prayer and dream of all human beings.

Psalm 84 sings:

How lovely are your rooms, O Lord of Hosts!
My soul yearns, pines for the courts of the Lord.
My heart and my flesh cry out for the living God.

Even the sparrow finds a home and the swallow a nest
Where she may lay her young at your altars,
O Lord, my King and my God!

Blessed are those who live in your house;
Blessed the pilgrims whom you strengthen to
 make their ascent to you. . . .
One day in your courts is better than a thousand
 elsewhere. . . .
I would rather be left at the threshold
In the house of my God than to dwell in any other.

And we pray:

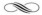

House of David, cedar of Lebanon, ark of the covenant, sheltering tree, tenement, shack, *favela,* shanty town, cave, house in a village where nothing good was expected to dwell, encircling arms, we give you thanks for giving God a home in your body. That welcome earth became a home for God and all of us again. May we welcome all on earth into our homes and make sure no one is homeless until we are all safe in the heart of our God. Amen.

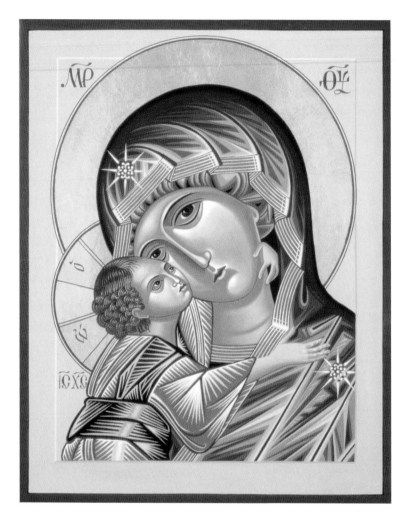

22

Our Lady of Grace, Vladimir

Ave Maria
Ave Maria! 'tis the hour of prayer;
Ave Maria! 'tis the hour of love;
Ave Maria! May our spirits dare
Look up to thine and to thy Son's above.
Ave Maria! Oh that face so fair,
Those downcast eyes beneath the Almighty Dove!

(Lord Byron)

That face so fair yet so anguished, so downcast, so drawn in sorrow, so overflowing with pain from deep within. It is as though the child knows the pain and turns, climbing up close, and wraps its small arms, reaching to encompass her, his face laid sure against hers, his other hand caressing and encircling her neck. It is the way children hug, in rhapsody, in delight, in terror, in sheer unabashed affection for those they cherish and love. It is a clutch of innocence. It is a little bear's grasp, sensing unshed tears and depth of emotion and wanting to make it all right again. "Come, mother, I love you. It will be fine. I will make it right and good again. Don't be sad."

The head of the mother is royally wrapped in purple and just as truly wrapped in her son and her God's stronghold of embrace. This is the Child-God comforting the mother-

107

loved, the roles reversed. This is the God of old, sung of by the prophets and the early church writers:

> As a mother comforts her son — so will I myself comfort you. (Isa. 66:13)

> God's only begotten, he who is in the Father's breast.
> (John 1:18)

And Thou, Jesus, sweet Lord, art Thou not also a mother? Truly, Thou are a mother, the mother of all mothers who tasted death in thy desire to give life to thy children. (Anselm of Canterbury)

> God is love. God can only be perceived in love.
> Father in his inexpressible being,
> Mother in his compassionate pity for us.
> In his love for us, the Father became woman.
> The great sign for us is this: He who was born.
> (Clement of Alexandria)

This is the tender mother, the lowly one, the poor woman, the unwed mother, the one watching her child leave her to go into the world, the mother witness to execution, the one watching a beloved suffer and die, helpless, beyond even a sigh, wracked with agony. This is the woman who has lost her child and cannot understand why he would go off and do this to her, causing her such grief (see Luke 2:41–52). This is the woman mourning on the day of death, yet pulled into unbelievable rejoicing at his resurrection.

And this is the strong child teaching the mother. This is the lady of grace, held in grace most free, most humble, most gentle and strong. This is the woman who has known God's

will in her flesh — its agonies and its raptures. This is the woman we hail and beseech when we are all in dire need and distress as she is pictured here.

∞

Our Lady of Grace, Mary, the Lord is with thee. Blessed are you and blessed is the fruit of your womb, Jesus. Holy Mary, Mother of God, pray for us sinners now and at the hour of our death. Lady of grace, hold us, as your beloved son holds you, comforting, turning all your fears and trembling to joy as he heals your broken heart. As children of God, teach us to hold one another, healing and freeing one another from fear and pain. May we know your son, your God, your Father, your Spirit, and you, O Mother, holding us all in grace, until forever. Amen.

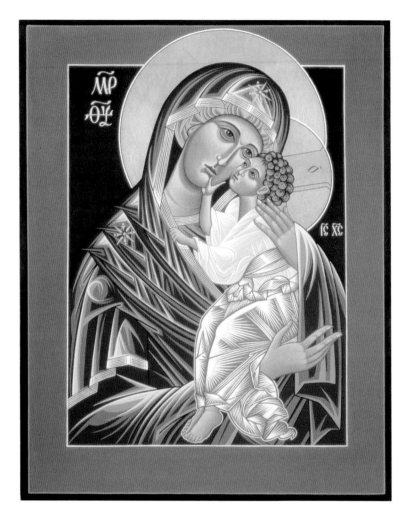

23

The Virgin of Tenderness of Yaroslavl

Behold thy mother! (John 19:27)

"Look now upon the face that is most like the face of Christ, for only through its brightness can you prepare your vision to see him." (Dante, *Paradiso*, 32.85–87)

This icon bespeaks the mystery of tenderness, the mystery of God's visit to humankind in flesh. This is the mystery of one woman's flesh joined to the power of the Most High, the Father, and overshadowed by the Holy Spirit (Luke 1). This is how our God looks in human face and form. Here is "the image of the unseen God, the firstborn of all creation, for in him were created all things in heaven and on earth: every-thing visible and everything invisible.... All things were created through him and for him" (Col. 1:15–16).

And here is the woman, beloved daughter of the Father, who was the child's mother, first disciple, dearest friend, and intimate of the Spirit. Here both are seen together — tender virgin and tender child born of hope, of love, of obedience and belief. This portrait seems to have been "written" in response to words of John Damascene in one of his homilies (Homily 3, Dormition) on Mary:

111

What is sweeter than the Mother of my God? She has taken my mind captive; she has taken possession of my tongue; she is on my mind day and night.

Between them there is unspeakable respect, regard, and sweetness. The feeling is so strong, so pure, that it almost hurts to look at them. An ache opens up inside us for such love to touch and enter our own bodies, minds, and souls. This woman is known by God and knows in ways that cannot be expressed, except through silence, sight, and touch. This child, when grown, taught his disciples in a prayer:

> I bless you, Father, Lord of heaven and earth; for hiding these things from the learned and the clever and revealing them to little children. Yes, Father, for that is what it pleased you to do. Everything has been entrusted to me by my Father; and no one knows the Son except the Father, just as no one knows the Father except the Son and those to whom the Son chooses to reveal him. (Matt. 11:25–27)

This is the mystery of knowing the Holy and being known back utterly.

The virgin is clothed in brown with touches of green, blue, and pink as though she were a garden in early spring. She is star-signed by the invisible twice, and on her left shoulder she carries God made human, God visible. She holds him delicately, hand to his shoulder and back, her other hand cradling him, carefully and so precious. And he has his face pressed to her cheek, one hand clutching her veil and the other lifting her chin, stroking her face. Their eyes are only for each other. Their garments flow, run like waters, are vo-

luminous like clouds and rays of light. They exude holiness and tenderness, which seep out like perfume filling the air around those of us who are allowed to gaze upon them in their intimacy.

This presence invites and prays us to "Come to me, all you who labor and are heavy burdened, and I will give you rest. Shoulder my yoke and learn from me, for I am gentle and humble in heart, and you will find rest for your souls. Yes, my yoke is easy and my burden light" (Matt. 11:28–30).

We pray:

O virgin so tender, you carry so lightly the bright holiness of the love of God. You gaze upon the desire of your heart and the delight of your life. You let us see the awesome humility of God made human in your flesh and God's wondrous beauty as one of us. Help us to know your Child-God and to know in our lives this tender regard. May we remember, looking at you and Jesus, that our God has made us to love us. Let us absorb that love in every part of our being and turn and love one another with that love and turn and love you back. May it be so, in the name of the Father, the Son, and the Holy Spirit, our God of infinite tenderness. Amen.

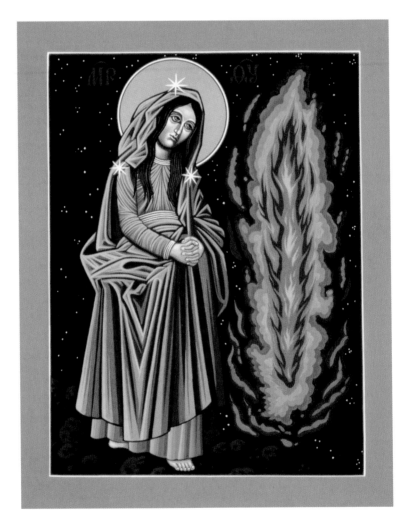

24

Bogorodice Kraljice Hodočasnika
(Mother of God, Queen of Pilgrims)

What grief bears down upon this woman who walks barefoot on stony ground! The night is dark but filled with innumerable faint stars — the galaxies witness and watch her as she treads her way so silently and so alone. Even the stones appear to be skulls, the remains of those left unburied, crying out from the earth.

She is pregnant, very pregnant, just days or hours from giving birth. Her clasped hands suggest more than prayer. They hold the pain of labor, of a body, a womb, and a heart about to break open. And yet she walks. She must. She is without shelter or privacy, at the mercy of the elements and whomever she encounters. She is a pilgrim, sojourner, migrant, refugee, asylum-seeker — some fleeing death or hate or destitution, all seeking solace, sanctuary, rest, a place of welcome, hospitality.

Her dark-hued clothes and posture testify to her journey — that it is forced, penitential, hard, dangerous, slow, and painful. She is in labor, bearing the brunt of others' hardness of heart and callousness — the reality of so many women, children, and elderly persons caught in the crossfires of war, ethnic cleansings, with old hatreds stirred up again, driving them from their homes and lands out into

the night, into jungles, and onto dangerous paths, mountain roads, with no mercy for their plight, and no respect or honor for the life they carry with them.

Her cloak is deep folds of purple. Her dress blue, but the blue of depth. Her hair the blue of deep waters, deeper night — it is the ancient blue of grief, of unshed tears, of the terrors of waters that sweep over whole peoples driven into exile, hunted, "cleansed," humiliated, tortured, raped, with both body and soul destroyed by other human beings forgetful of their own dignity and responsibilities toward others. She is the woman of Kosovo, of Northern Ireland, of Iraq, of the West Bank of Palestine, of Sierra Leone, of Kibecho, of Chiapas, of Acatal, and of so many places. The litany makes tears rise, voices choke, and hearts ache.

But she is not alone. She has the company of the presence of God, the Shekinah, God-in-Exile with the people — the chosen, the *anawim* of Yahweh who were accompanied by a cloud by day and a pillar of fire by night, protecting, reminding them of God's power, election, and intent to bring them to safety, to a place of repose, refreshment, freedom, and liberation. This is God the Father and Spirit attending to the woman about to give birth to the Son of Justice who will shatter the night of sin and hate. She stands on all this world's hills of sorrow. We do not learn and do not change, and so she bears still her children's pain, the rejection and fear of all earth's exiles.

But the Spirit that hovered over the waters hovers over this woman. The Spirit that spoke through the prophets speaks through her flesh, crying for justice. Silently it screams with all those torn by hate's clawed hands. This is the Spirit that subdued the chaos, confirms all hope, and

restores the earth to wholeness. This woman's womb will make us a garden again.

Mother of God, Queen of Pilgrims, let your spirit and God's Spirit steal softly upon us. Make integrity and peace to grow from seeds of forgiveness. May true wisdom distilled from your sighs and tears fall upon us. From the beginning, such anguish enfolded you, O Mother, along with your son. Yet your mantle of justice hides your fierce prayer and belief. Give birth to us now and throw wide your mantle to let God's Spirit draw near to us in fire, in courage and holy presence. Be our refuge. Amen.

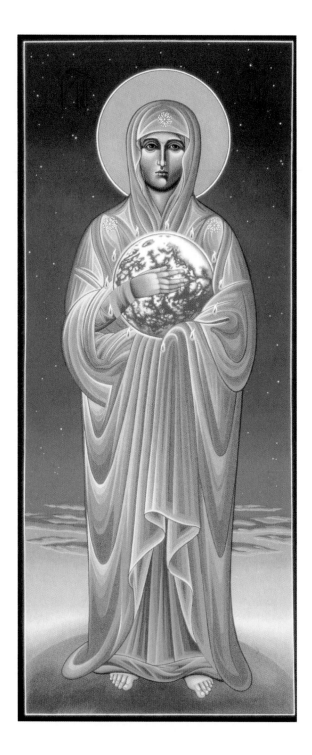

25

Mary Most Holy,
Mother of All Nations

Hail! Mary Most Holy, Mother of All Nations. You are Wisdom wrapped in silence and saffron standing barefoot on earth's molten core. You cradle the world haloed in the Spirit's fiery tongues. You are Trinity-marked on forehead and shoulders, and your eyes summon us to reflect and repent on the fate of all your children. You are standing at the foot of the cross still.

And yet God has clothed you in the soft fiery glory spun of the obedience that was your first garment of grace. You bear us all with the same love you gave your firstborn child. Mother, you still hold the deepest hopes of God for us: "Peace on earth for all upon whom God's favor rests" (Luke 2:14).

Mary Most Holy, Mother of All Nations,
help us recall that the universe is one song of praise,
and we are all created to be the beloved of God.
Make us all one in the Trinity.
All nations. No nations. No boundaries, only expanses.
No borders, only homelands.
No separations, only communion.
As it was in the beginning. Amen.

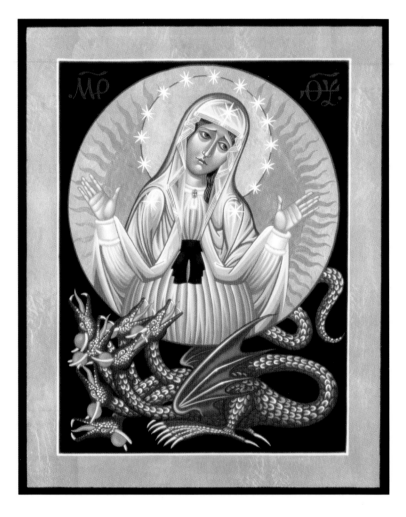

26

Our Lady of the Apocalypse

Now a great sign appeared in heaven: a woman, robed with the sun, standing on the moon, and on her head a crown of twelve stars. She was pregnant, and in labor, crying aloud in the pangs of childbirth. Then a second sign appeared in the sky: there was a huge red dragon with seven heads and ten horns.... Its tail swept a third of the stars from the sky and hurled them to the ground, and the dragon stopped in front of the woman as she was at the point of giving birth, so that it could eat the child as soon as it was born. The woman was delivered of a boy, the son who was to rule all the nations with an iron scepter, and the child was taken straight up to God and to his throne, while the woman escaped into the desert, where God had prepared a place for her to be looked after. (Rev. 12:1–6)

This is the woman pregnant with the long-awaited Holy One, the hope of the ages. Or, as St. Catherine of Siena wrote: this is the one "who has shown us great love still by giving us yourself, shutting yourself up today in the pouch of our humanity." This is the woman "whose womb is more spacious than the heavens" (Panagia prayer, Russian). This is God's "Forth-bringer." She is terrible and pitiable to look upon, in mortal danger, about to give birth to her child

whose name means "save his people from their sins" (Matt. 1:21). She is in labor, horror looming before her — Evil that seeks to eat her child. She must give birth. The time is filled. God's will and power will be made manifest, made human, for the earth. And so the powers of hate, of sin and injustice, amass together to hinder her from bringing light and grace, the person of God, into the world.

But she prevailed with the help of God and his angels, in the face of brutal massacres of the innocent and political and economic powers intent on snuffing out the life of her new-born and, later, equally rabid in their attempt to malign and murder the man grown to Wisdom, God-with-us, Emmanuel. With the birth of her child, history shifted and a rift opened in the universe. God's humility and love were let loose.

But we read soon after that a battle broke out in heaven between the angels and Satan, the hinderer, the dragon. It was fought and won there, and the dragon was cast to earth. Here the battle continues. The dragon pursued the woman into the desert. She was given eagle's wings to escape. Then the dragon countered by "vomiting water to sweep her away in the current; but the earth came to her rescue" (Rev. 12:15–16). And now we hear of our own predicament: "Then the dragon was enraged with the woman and went away to make war on the rest of her children, who obey God's command-ments and have in themselves the witness to Jesus" (Rev. 12:17). And the battle rages on. We are told: "This is why the saints must have perseverance and faith" (Rev. 13:10).

This woman's situation silently screams for attention, for us to be on guard, to respond quickly with courage to her in her vulnerability. We are to aid her, to midwife her birthing. The tilt of her head and her eyes plead beggar-like, imploring

us who look upon her, to be moved to pity, to just and righteous anger, and to put ourselves between her and the dragon for her protection. The church is this woman on earth. We are the church, her children born in the blood of the cross, born in the death-grip that was broken in Christ's resurrection. The dragon's followers, the enemies of truth and the destroyers of the lives of the poor and the faithful, hinder the coming of justice and peace on the earth, hinder the church in its mission of salvation. But we must remember to take heart from the words: "Then I heard a shout from heaven, 'Salvation and power and dominion forever have been won by our God, and all authority for his Christ, now that the accuser, who accused our brothers [and sisters] day and night before our God, has been brought down. They have triumphed over him by the blood of the Lamb and by the word to which they bore witness, because even in the face of death they did not cling to life'" (Rev. 12:10–11). And later: "Look here, God lives among human beings. He will make his home among them; they will be his people and he will be their God, God-with-them. He will wipe all tears from their eyes, there will be no more death, and no more mourning or sadness or pain. The world of the past has gone" (Rev. 21:3–4).

Our Lady of the Apocalypse, "we hail you, O Mother, heavenly being, Virgin-throne of God, the glory and bulwark of the church; pray for us constantly to Jesus your son, our Lord, that through you, we may find mercy in the day of judgment, and attain to the good things laid up for those who love God" (John Chrysostom). Amen.

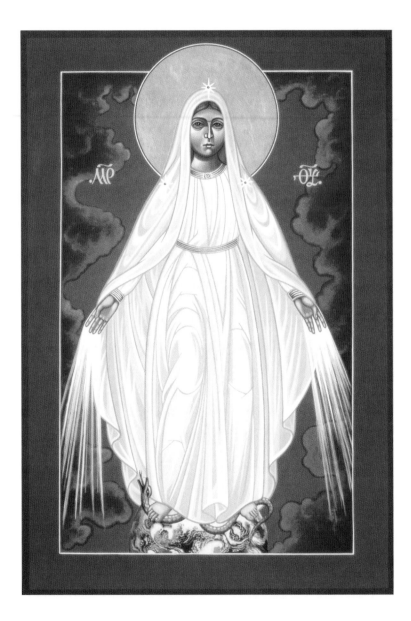

27

Our Lady of the Miraculous Medal

Startlingly, this woman dressed in white and blue stands against a fiery red backdrop. It is as though she is the inner, blue, white-hot flame that is visible when one watches a fire. Utter simplicity marks her garments, highlighting her wide-open arms — as though seeking to reach for a universe to hold within her embrace. And yet her stance is graceful, full of grace, casting rays of light upon all the earth.

She stands on the earth — it is her foundation — and steps barefoot on the serpent. This is the woman promised at our beginnings, in the garden where the struggle for goodness began on earth among humans. Surprisingly, the promise is enfleshed in her. "I will make you enemies, you and the woman, your offspring and her offspring. He will crush your head and you will strike at his heel" (Gen. 3:15). These are the words of God to the serpent about the child that will come forth from this woman — Jesus, Son of God, son of Mary, Savior.

The lady is young; she is virgin-robed. This Mary renders her name's meaning visibly. "Mary signifies Light-giver or Star of the Sea; for she gave birth to the Light of the world. In the Syriac tongue, however, Mary means *Lady*, and beautifully so, since she gave birth to the Lord" (Isidore of Seville, *Etymologies*). But her name, Myriam, is also translated as "sea of bitterness and sorrow," depths of grief, in many ancient

languages. This is the lady of miraculous intercession, desperate resort of those in distress, dire circumstances, human misery, poverty, loss, and death. She is recourse in time of travail and fear.

This is the woman who faced the fire often in her own life, even when she was young. She lived in occupied territory with the threat of violence present everywhere, knowing her own life and that of her child were in jeopardy, even before he was born, for under the law she would face death by stoning for conceiving a child while only betrothed. Even the birth of this child is marred by the cries of horror — mothers and fathers weeping at the massacre of their children because of Herod's fear and jealousy at the birth of one who would be the hope of the people, "a leader who would shepherd the people Israel" (Matt. 2:6). The prophecy continues with the words "He shall be peace" (Mic. 5:5). She is the lady who brings peace into a world beset by terror, war, destruction, and hate. Miraculously she brings life to every situation, every place, every heart. She is everyone's lady. Nothing, no one, is left unheard, alone, or unanswered. Her heart, like her womb, is wider and more spacious than the heavens. It has been opened by love.

Thérèse of the Child Jesus, of the Holy Face, the Little Flower, and Doctor of the Church (1874–1897), wrote a prayer to Mary:

Virgin, full of grace, I know that at Nazareth you lived modestly, without requesting anything more. Neither ecstasies, nor miracles, nor other extraordinary deeds enhanced your life, O Queen of the Elect.

The number of the lowly, "the little ones," is very great on earth. They can raise their eyes to you without any fear. You are the incomparable mother who walks with them along the common way to guide them to heaven.

Beloved mother, in this harsh exile, I want to live always with you and follow you every day. I am enraptured by the contemplation of you, and I discover the depths of the love of your Heart. All my fears vanish under your motherly gaze, which teaches me to weep and rejoice!

You, O Lady, by God's miraculous design are mother of us all. O Lady of Miraculous Love, answer our deepest needs and the prayers we cannot put into words. Bring light. Bring hope. Bring peace to our lives and to all the world — again, as once you brought forth your child. Bless us, O Lady, and look upon us with the light of Christ that shines in you for all to see. Amen.

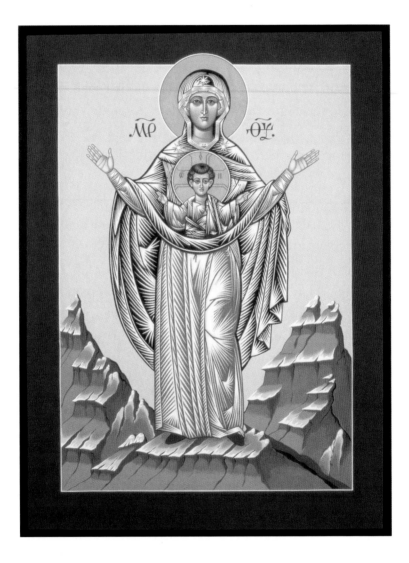

28

Our Lady of the New Advent, the Burning Bush

This icon is based both on the miraculous healing Mirozh icon of the city of Pskov and on the beautiful fourteenth-century Spanish hymn to the Mother of God, "O Virgo Splendens," which says,

> O resplendent Virgin,
> here on the miraculous mountain,
> cleft everywhere by dazzling wonders,
> and which all the faithful climb,
> behold them with your merciful
> eye of love. . . .

We stand on a threshold, at the advent of the third millennium, the reign of God, a thousand years of mercy and peace for all upon the earth. Do we stand, as this woman stands, on the mountains? She is the first to hear and become a believer in the gospel, a proclaimer of God's joyful presence in the world.

This woman of Advent is a woman of the Word made flesh — made of her flesh and the Spirit's overshadowing fire. God was first revealed to Moses upon a mountain in the presence of a bush that burned but was not consumed. This bush, this tree of life, was rooted in God's compassion.

The announcement "I have heard the cry of my people, enslaved in Egypt, and I have come down to save them" (Exod. 3:7–8) was the reason for Yahweh drawing close to earth to speak with Moses. And Moses is sent to liberate the people of God and draw them out of bondage, draw them into the covenant and freedom — making them a people. It was the advent of hope and mercy.

Generations later, God bent down again, intent on coming closer to us, and beseeched a young girl for help in saving the people from their sins. And she stood, attentive and hearing the Word, ready — "Here I am, Lord. May your Word be done in me" (Luke 1:38). Evangelization began with her obedience. Now as disciple and mother she stands on the mountains of the earth burning with expectation, for her child to be born again in our hearts by conversion, the practice of forgiveness and mercy. She seeks to bring her son — borne in her womb, carried still within her to us — to seed our lives with new fire, mercy's fire. She comes as mother, as sister, as disciple and preacher, as missionary, as the presence of God among us, as faithful daughter of the Holy Spirit, and as a member of the community of believers.

We, like Moses, must come near, come together, into this next millennium, redeemed by her son, converted to God's will, brothers and sisters and mothers to her son Jesus the Christ. Words she once heard or overheard him say — "Who is my mother, brother, and sister? . . . Anyone who hears the Word of my Father and puts it into practice is mother, brother, and sister to me!" (Matt. 12:48–50) — are now put before us. She obeyed and put into practice, put into her flesh and life, the Word she heard. And she set out into the mountains bringing this Word to the house of Elizabeth near

Jerusalem. She was first to be blessed. "Blessed are the feet of she who brings Good News!" We are reminded of the words of a Quranic saying, "Paradise is under the sole of mother's feet."

We pray:

∾

O radiant sign and example of Christian life, awaken a song in us your children, a response to the gospel call to repentance and a burning desire to be reconciled with one another. Yearning for holiness, we unite in prayer so we may be transformed by grace into mercy for one another. May the mountains resound with the echo of our feet, with the sound of our praise, and may all the earth rejoice to hear the cries of gladness as a new people is brought forth in this age. Amen. Amen. Alleluia. Amen.

(NOTE: The feast of Our Lady of the New Advent is celebrated on December 16 in the archdiocese of Denver.)

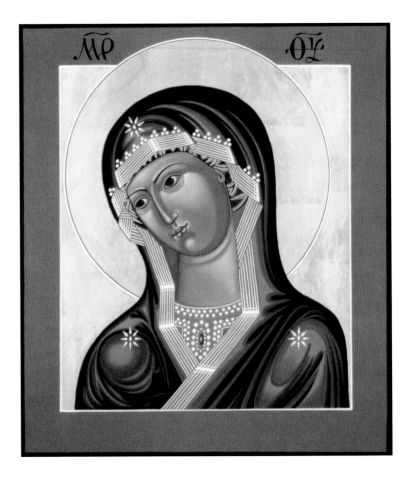

29

Mother of God, Similar to Fire

O Mother-Maiden! O Maid and Mother free!
O bust unburnt, burning in Moses' sight!
That down dist ravish from the Deity,
Through humbleness, the Spirit that did alight,
Upon thy heart, whence, through that glory's might,
Conceived was thy father's sapience!

(Geoffrey Chaucer, modernized by William Wordsworth)

There is no escaping these eyes, this burning woman, this radiant spirit and her secret thoughts revealed! This is a star that held God close on earth. A sanctuary for the unquenchable fire of love — God made flesh in the Son of Man, the son of Mary. This is the woman who pondered all these things in her heart (Luke 2:19, 51b). This is the woman praying; the Spirit praying within her, teaching her to pray; her child, the life of God in her, bursting through her flesh. She is the burning bush that is not consumed, the burning bush of the New Testament.

She prays in the ancient ways of prophets: to honor God, to raise the poor, to do justice and bring mercy upon the earth. This burns all that is not of God to dust and ash. She is a holy flame burning fiercely to illumine the darkness of evil and sin. She is wrapped in fire as in a robe. She is a lamp that ever glows, silently announcing sanctuary, and piercing

the hearts of all who seek God. Her presence sheds light as her son's side was pierced and blood poured out, unleashing the Spirit into the world.

We are told by the Jewish rabbis: "Now Mt. Sinai was altogether in smoke, because the Lord descended upon it in fire!" (see Exod. 19:18). They are telling us that the Torah is fire, was given in the midst of fire, and is compared to fire. As the way of fire is, when one is near it, one is burned, but when one is far from it, one is chilled — so the only way is to warm oneself in the light. In Luke we are told how to recognize the unmistakable presence of the risen Lord among us — "Were not our hearts burning inside of us as he talked to us on the road and explained the Scriptures to us?" (Luke 24:32). This is the woman of the Word, similar to fire, Mother of God.

Lady, may you spark within us a desire to pray. Make our hearts burn within us. Purge us of fear and sin. Bless us with the fire of the Spirit that overshadowed you, and ask for us the gift of prayer. May the Word made flesh in you warm us and make us torches revealing God to the world! Amen.

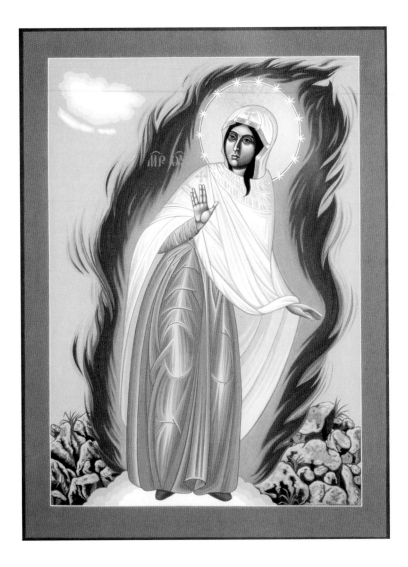

30

Mother of God of Medjugorje, the Burning Bush

I beg you, dear children, beginning today, start to love
with a burning love, the love with which I love you!

<div align="right">(Mary to visionaries, May 29, 1986)</div>

This Mother of God of Medjugorje is a living flame of love.
She is a prophet, crying out in the wilderness for humankind
to return to God and know the vibrant love that God has
always lavished on his people. She is reminiscent of God's
presence when the Israelites came out of Egypt, when "Yah-
weh preceded them, by day in a pillar of cloud to show them
the way, and by night a pillar of fire to give them light, so
that they could march by day and night" (Exod. 13:21). This
passage ends with the statement that the cloud and the pil-
lar of fire never left them. Later in Exodus the people are
summoned to the holy Mount Sinai, but are warned not to
touch even the edge of it. They assemble and the moun-
tain is engulfed in smoke "because Yahweh had descended
on it in the form of fire" (Exod. 19:18). The whole event
is wrapped in fear and power barely contained that shakes
the very foundations of the earth. And it is in this atmos-
phere that God reveals the covenant's binding laws to the
people.

This is the revelation for God's people in these days. The cloud hovers over the new burning bush that stands as a fierce candle flame, a beacon bright that is not con- sumed, but is lasting, faithful. Mary stands again on the earth, bringing Old Covenant and New Testament together in her person. She is a Hebrew prophet and a disciple of the crucified Christ, wrapped in the white garment of those bap- tized in the blood of the Lamb. In her often-repeated words and presence she summons God's people to once again refuse to serve the idols of dominance, oppression, materialism, and self-centeredness, and to believe wholeheartedly in the sum- mons of God made visible in her child who loved — loved even unto bitter death, leaving us fresh manna, the food of his body and blood.

This is the Mother of God of Medjugorje whose words are most clearly understood in the tradition of the prophets, psalms, and foremost in the words of her own son, revealing God the Father and the Spirit, the God of the Trinity and community. If we hear and heed her voice, her insistent presence upon the earth, in the midst of those oppressed, driven from their homes, enslaved, and destroyed, we will respond with love — great love both for the earth itself and for all her children. We are each called to burn, to be pillars of fire, to be God's presence, warming and transforming the world together. Listen to two persons who understood what this word of God is now calling forth in us:

> Throughout my whole life, during every moment I have lived, the world has gradually been taking on light and fire for me, until it has come to envelop me in one mass of luminosity, glowing from within, ... the purple

flush of matter imperceptibly fading into the gold of the spirit, to be lost finally in the incandescence of a personal universe. . . . This is what I have learnt from my contact with the earth — the diaphany of the divine at the heart of a glowing universe, the divine radiating from the depths of matter a-flame.

<div align="right">(Pierre Teilhard de Chardin)</div>

We who taste in prayer and study the fire of God's truth and love for us are inescapably called to rise up impassioned for the world's healing. (Catherine of Siena)

Today we must draw nearer to the burning bush, renew our baptismal covenants, and feast together on the flesh and blood of the Son of Man, caring for all in such a way that "our light will shine before others who see our good works, and so give praise to our Father in heaven" (Matt. 5:16).

O Mother of God of Medjugorje, shed light in all the darkened corners of our world and help us to heed again the summons of the Word of God. Help us to draw nearer to your God, to live in truth, freed from sin, in service to others most in need, with the burning love of our God. May we honor your words and imitate your obedience and unbounded love for all the human race. We ask this in the name of the Trinity. Amen.

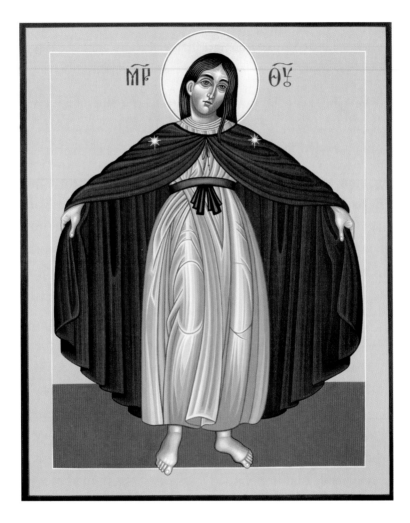

3 1

Mother of the Poor,
Mary of the Magnificat

This woman stands with mantle spread wide, coming toward us. God's love and mercy came into the world through her, and now she hastens to bring this incarnation, this word of God, into the whole world. She walks on the way, head uncovered, and cloak open — as open as her heart, her body, and her spirit were to the invitation from God. She is pregnant — the traditional black band tied about her waist, encircling her womb, proclaims publicly that she is bearing a child into the world. And it is not just any child, but the child who will give birth to a new creation.

She goes simply, barefooted, as a servant. She steps lightly over the threshold, from one millennium to the next, from a hill of praise to a hill of pain, from one country to another, dancing between earth and heaven. She is Mary who sings as she walks, as she obeys, as she hastens to all those in need of her voice, her submissiveness, her presence, her prayers, and the one she carries safely beneath her heart.

The graceful green folds of her dress outline her strong legs as she strides toward us. Her dress runs with rivers, hidden folds of grace, growth, and hope. She is a woman missioned, Spirit-driven, Spirit-led.

Magnificat! She stands in freedom! She has paradoxically stood at the cross as *stabat mater dolorosa.* She has stood in the shadow of the sword that pierced her soul to its roots, and she has stood in the shining mercy of the Holy One of God, her child risen from the grave. Her robe runs deep with blood lines of royalty, of suffering, and of birth pangs. She has stood on the threshold of two covenants, in the Cenacle and the Upper Room, on the threshold of the church and the world. Now she stands on the threshold of the whole universe and the threshold of every human's heart, before every child of God.

As always, she is starred, on forehead and shoulders, reminiscent of Guadalupe, "the star of the evangelization of all America." This is the woman "Mary [who], by her motherly and merciful figure, was a great sign of the closeness of the Father and of Jesus Christ, with whom she invites us to enter into communion" (John Paul II, *Ecclesia in America,* no. 11). But she is more than invitation. As she comes toward us, she comes in search of those who need her most: the poor, the enslaved, the ones running from violence, the destitute and the desperate, the hungry, the indigenous, all those who cross thresholds of race and religion, and especially the ones who die reaching out for life and tenderness. She comes to throw her mantle of justice over all, to embrace and draw us all closer to her heart and to the heartbeat of her first-born child, Jesus the Christ. After that firstborn child, there have been, there are, so, so many others — crying, mourning, suffering, struggling to be born, needing her mothering, her nurturing, her touch, and her presence. In the words of St. Ambrose, although "Christ has only one mother in the flesh, we all bring forth Christ in faith. Every soul receives

the Word of God." We are each born to be both child and mother, as she was in her life.

We pray:

∞

Woman of the Magnificat, servant-singer, lowly and lovely lady, coming in haste with the compassion of God surging beneath your flesh, gather us under your cloak. Remind us that there is room for all of us, and there is a welcome abundance of mercy. Let us rejoice with you, tell of the deeds of God again and again, and cry out with you of the honor of God, the care of the poor, and the coming of justice. You, Mary, are the music of God. Your presence moves on all the roads, and you step first over the thresholds of the homes of the poor. In your dark countenance and strong hands God's flesh is exposed and we know we are loved, saved, and embraced by God in the light that dawns upon us in your great "Yes." In imitation of your stance before God, may we stand open-hearted with arms extended toward one another. May we who are born of grace be the beloved children of God and your children who walk to every corner of the earth. We ask this in the name of the Trinity, the Father, the Son, and the gracious Spirit. Amen. Amen. Alleluia!

A Prayer to Mary

Stillness of God, settle in our souls. Breath of God, move through us. Light of God, illumine our nights and dawn in our hearts. Shadow of God, fall over us as once you bent over the face of Mary and sow the seed of holiness, of justice, and of mercy within us. Whisper of love and truth in our waiting hearts. As we have gazed on these faces and forms of light, make us icons of your reflection for all the world to see. Mary, you who learned the wisdom of mercy and lived in its mystery, share that knowledge with us. May we hear again your words to all of us: "Do whatever He tells you!" (John 2:5). Give us the courage to walk through the world, intent on giving birth to your Word, your hope, and your love, steadfast until we find ourselves gathered into you, O Trinity, at home with this woman who believed, exalting together in the fullness of the freedom of the children of God. Amen.